Set the Action!
Creating Backgrounds for Compelling Storytelling in Animation, Comics, and Games

Elvin A. Hernandez

Focal Press
Taylor & Francis Group

NEW YORK AND LONDON

First published 2013
by Focal Press
70 Blanchard Road, Suite 402, Burlington, MA 01803

Simultaneously published in the UK
by Focal Press
2 Park Square, Milton Park, Abingdon, Oxon OX14 4RN

Focal Press is an imprint of the Taylor & Francis Group, an informa business

Notices
Knowledge and best practice in this field are constantly changing. As new research and experience broaden our understanding, changes in research methods, professional practices, or medical treatment may become necessary.

Practitioners and researchers must always rely on their own experience and knowledge in evaluating and using any information, methods, compounds, or experiments described herein. In using such information or methods they should be mindful of their own safety and the safety of others, including parties for whom they have a professional responsibility.

Product or corporate names may be trademarks or registered trademarks, and are used only for identification and explanation without intent to infringe.

Library of Congress Cataloging in Publication Data
Hernandez, Elvin A.
 Set the action! : creating backgrounds for compelling storytelling in animation, comics, and games / Elvin A. Hernandez. – 1 [edition].
 pages cm
1. Space (Art) 2. Composition (Art) 3. Animated films. 4. Motion pictures—Setting and scenery.
5. Comic books, strips, etc.—Technique. 6. Video games—Design. I. Title.
 N7430.7.H47 2012
 777'.7—dc23

ISBN: 978-0-240-82053-8 (pbk)
ISBN: 978-0-240-82055-2 (ebk)

Typeset in Futura Light
by MPS Limited, Chennai, India

Contents

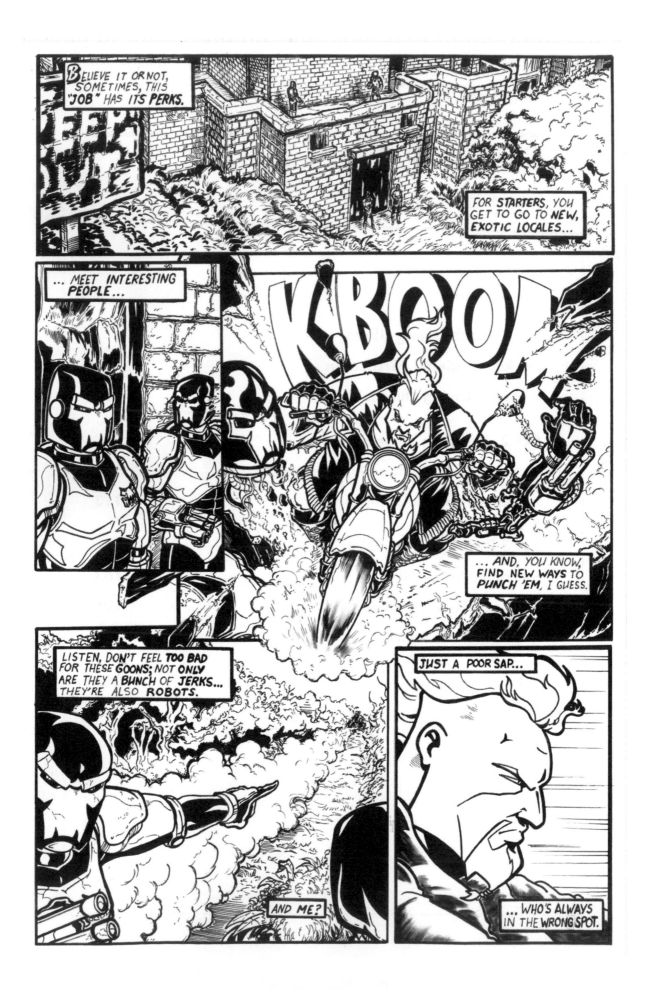

Introduction

Permit me, if you will, the chance to paint with words an all-too-familiar picture: a young illustrator is waiting in line at a comic book convention, hoping to speak with the senior editor of Whatever's Awesome This Month Comics. As the line gets shorter and shorter, the young artist beams with confidence. He knows full well that his portfolio, filled with powerful figures in exciting action sequences, will knock this particularly stodgy editor's socks off. Finally, he stands in front of the editor, who turns each page slowly, studying every panel, while our hero stands quietly, waiting for some much expected praise and recognition. Putting the portfolio down, the editor looks up, locks eyes with our friend, and says, "That's nice, kid . . . but where are the backgrounds? You telling me these guys are fighting over *nothing*?!"

The truth of the matter is that given an option, a lot of aspiring artists would gladly answer "yes" to that question. Backgrounds are generally relegated to the "boring" parts of the visual narrative process. Even as kids, we've gravitated toward drawing the characters rather than drawing their worlds. That's because instead of relating to the worlds they live in, we tend to connect with the characters first. We learn to draw superheroes, funny cartoons, or just about any character that strikes our fancy, and then we draw some boxes behind them, some green grass (in crayon, one color), or even leave the page blank with no backgrounds, unaware that we are still missing a vital character in our little play on paper.

Confused? Well, try this: think about your favorite story or scene from any particular genre. Chances are good that their environment had an incredible part in the plot's development. I mean, seriously, without a city to defend around them, your favorite heroes would just be weird bullies with capes punching out (mostly) deformed saps for no good reason. They need their cities (whether crystalline beacons to a better tomorrow or dark, art-deco nightmares), space stations, secret caverns, or dormitory basements to help us understand their motivations as well as their goals. In short, these sets make up the iconography that sticks with us, the readers, and helps us remember their story.

Now, I can see you dragging your feet a bit, and I can sort of understand your dismay; I too have looked at some point at a perspective grid and taken stock of the decisions in my life that had led me there. But that's because we tend

to see perspective as an overly precise measurement that needs to be studied down to the minutiae, missing the key reason behind perspective in the first place, which is that it's not about how it's done but rather what it's being done for. Perspective is an illusion on paper of relative space, and once you get past the rigid elements (such as equations and measurements), it becomes the window through which we interpret our world.

See? Doesn't that sound better already? Ah, but that's just the beginning.

Within these pages, we'll explore not just how to build an environment but also how to build a world. We'll take elements of character and concept design and adapt them towards the goal of environment study, tying both concepts together. You'll also study facets of art design, color, texture, and format as you discover how to create places that help define events and how to take your audience on a storytelling journey that will leave them craving more adventure!

Think about those poor drawings from your childhood . . . running around and living out your wildest dreams but with no place to call home. Well, no more. From this moment on, our warriors, damsels, and buffoons will have castles, villages, and dungeons worthy of their majesty—and what's more, they will be of our own making! (Cheers are optional at this point. I won't judge.)

All right, then, enough with the chatter. Let's start building ourselves some dynamic backgrounds!

Act 1

Establishing Shots!

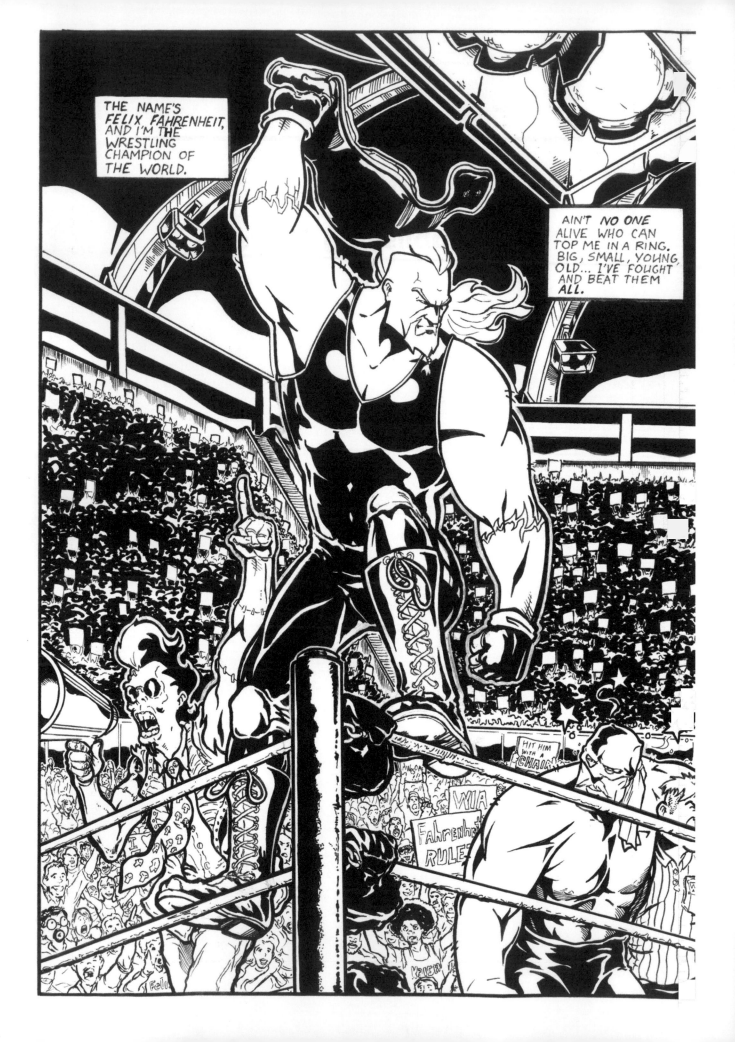

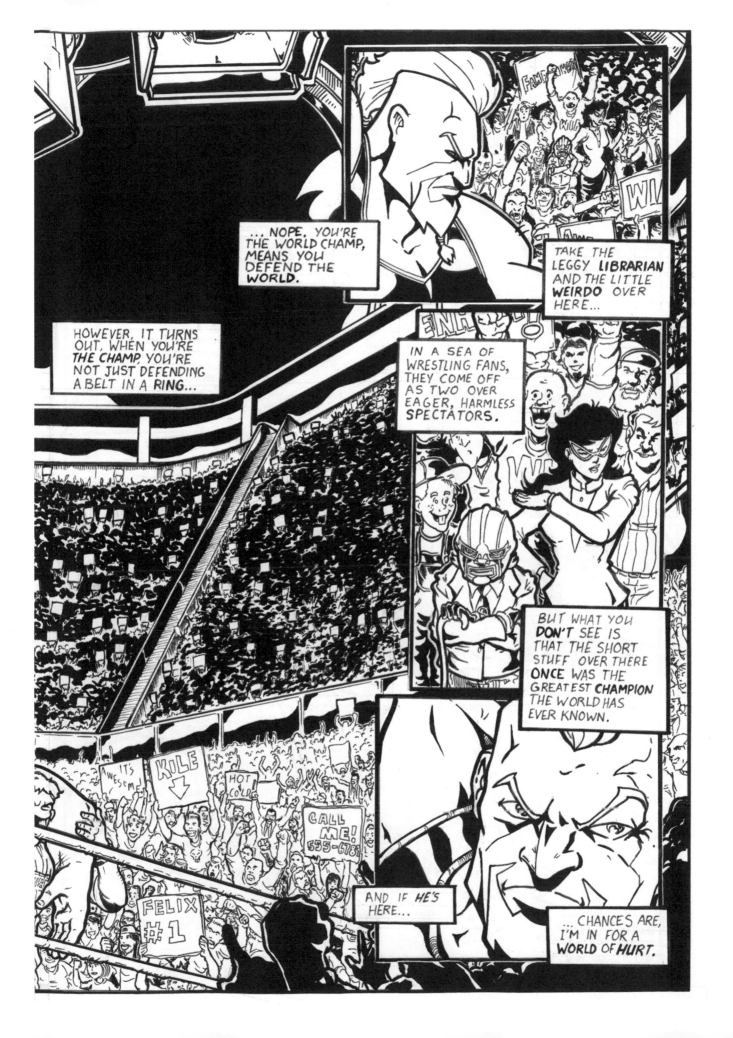

Section 1

Gaining Perspective

Just as Mr. Fahrenheit, the hero of our concurrent story, is about to enter into some strange mission, we are about to enter into one of our own: understanding and exploring perspective layouts. It's not the most glamorous of jobs, but it is a necessary "evil," and one that gets a bad rap. In all actuality, as part of a visual tradition, a universal language that predates the media arts and actually relates to our earliest forms of communication, environments are just as strong an element as any character or act displayed.

First, however, we've got to learn to walk, before we run (which is a stupid saying, because *of course* we learn to walk before we run—just ask a baby). We need to learn how to set up a particular scene in order to better develop the action that will be played upon it. That means we have to discuss (gasp!) *perspective* and *layout*. I know, I know… I can hear you groaning from here. Still, we need to develop those skills that will better help us design strong backgrounds in order to aim and enhance them toward any particular story or image, through which we'll create fully engrossing and dramatic visuals

that connect with the viewer and create memorable experiences on paper or on screen. Think of it as a first step towards an even greater world of adventure! There, isn't that already more exciting?

To all of you still groaning, I apologize for the corniness of my delivery, but let's push forward, folks!

WHY WE NEED PERSPECTIVE

To better understand the extent of the value presented by the question of why we need perspective, we should first decide how we are going to be defining perspective for the purposes of this book. Well, I did a little checking and prodding, looking the word up in different dictionaries and encyclopedias to get a better sense of how the world defines it, and I think we can agree on the following: *perspective* is all about *dimensions* and *depth*.

Depth, or in this case depth in design, implies the illusion of distance (a three-dimensional element) in a two-dimensional plane. In other words, it's the trick by which objects seem closer and further away in what essentially is a bunch of pencil or ink lines on a piece of paper. This effect can be achieved with the use of line weight and color (elements that we cover in future chapters), but it is certainly made easier through the proper use of perspective.

If you look at the following pieces (done by a five-year-old, a two-year-old, and a nine-year-old, so don't hate; I rather like it), you'll see a couple of completely adequate interpretations of an environment, with a very defined space and recognizable details found in our world:

Even though each interpretation here shows different levels of competency, due to their ages, we can definitely understand each as a representation of the world surrounding these kids. However, these pieces tend to be flat and one-dimensional, with only a rudimentary understanding of space—which,

as it turns out, is not far off from how art looked for quite some time. If you view any Egyptian hieroglyphs or some medieval woodcarvings, you'd see characters and buildings sharing one particular plane. The artwork was symbolic and illustrated events as well as characters clearly, but it didn't quite imitate the depth and dimension of the real world (this is not to say that all art was like this during these periods, or else we wouldn't have statues from the Greeks or the Egyptians—but it would be during the Renaissance, a period of intellectual and artistic rebirth after the Dark Ages, where art started to imitate the depth of an actual livable environment).

To illustrate this point further, I present the following image:

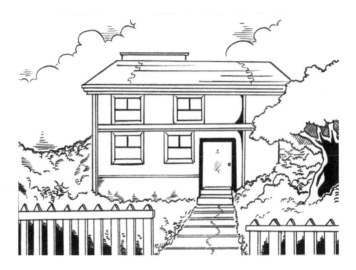

Ah? See? This drawing presents a similar image to the previous piece, with the same elements in design within the drawing, yet with the added element of depth and line weight. Suddenly, the environment feels like characters could inhabit it more readily, as well as adding to the illusion of an even bigger world surrounding it. In short, it feels *real*.

Thus, we finally arrive at our definition of perspective, the one we will be employing in this endeavor: *perspective in layout design* is a visual trick that allows for the illusion of dimension and distance within a two-dimensional medium (the page, as it were).

Well that sounds… wait a minute! *A trick, you say!?*

Yup. A trick.

Truth of the matter is that although perspective adds a sense of space to a drawing, it's based on the notion that all lines go towards a particular point on the horizon (more on this later). However, due to the fact that we live and build upon an Earth that's anything but flat, if we were to line up a perspective grid using what we see out of our windows as our reference point, most of what you see outside would *just about* line up, but not in a completely perfect line within said grid. Perspective, or the study of it, adds to the illusion of an even horizon and creates what the viewer considers to be actual dimensions on land. There are circumstances in which this illusion can be used to cover areas where the horizon is not clearly defined or is in a different spatial relation to several elements of a particular scene (this effect is called *zero point perspective*, and we cover it in different sections of this book, but, for now, let's stick to the basics).

Perspective also helps the viewer understand and implement the basic concept of *mass* on paper. Mass is, much like depth, an illusion, but in this case it pertains to the physical aspect of a particular object or element in real space or rather the space provided in the image presented. In other words,

whereas depth is all about the distance between objects, mass is about the actual space a particular object occupies. Here's a perfectly adequate example:

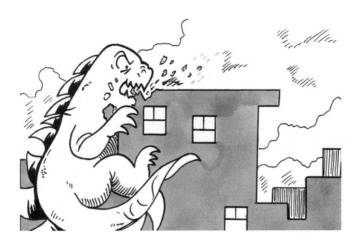

Once again, the story is present in the scene (a giant lizard attacks a city), but the situation loses dramatic context because the scene just doesn't feel real or natural. However, if we were to change the angle of the image and present the same scenario in a different light:

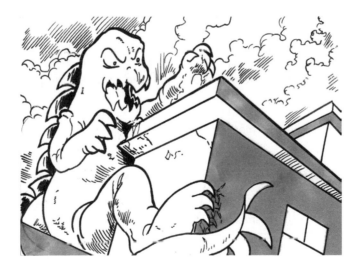

Well, that's more like it! Carnage!

The scene attains a dramatic push by adding depth and mass to the equation. Suddenly, the lizard monster is an actual threat, and you can connect with the events of the scene at a more personal level (or as personal as giant lizard attacks get).

In the end, all elements of design—perspective, line weight, composition, color, or any number of features that make for an effective artistic piece—derive from the *purpose* or *focus* that is being projected throughout. I'm talking, my friends, about *story*. The viewer must connect with the central concept of any illustration, comic, or game being viewed, and to do so, all the elements of design must work in tandem to achieve this goal.

In this book, my ultimate goal is to present the components of spatial design (environment study) to enhance dynamic storytelling in the visual arts. Later chapters expand on different concepts for a full understanding of their narrative use.

Think of it as adding elements to your artistic utility belt (actually, don't—that sounds stupid).

THE HORIZON, EYE LEVEL, AND THE CONE OF VISION

Now that I've established the ultimate goal of the study of perspective, let's start viewing its basic elements, starting with the horizon.

As discussed in the previous section, we used to think that the world was flat—that is, until people far braver than I sailed the ocean blue and found that it went beyond that deceptive line at the edge of forever that gave the impression of a very flat surface.

Well, that line that created all that fuss was called the *horizon*. The horizon could be best defined by physical elements (by what you can or can't see). Essentially, it's the farthest point on which the eye can rest on a particular plane or surface up to the point that the actual landscape begins to curve downward, adhering to the roundness of the planet. We can't really see the bend from the point at which we stand, which is where the illusion of a flat surface comes from. It's also where the concept of depth begins. For example, here's an illustration of an environment going onto a perceived horizon:

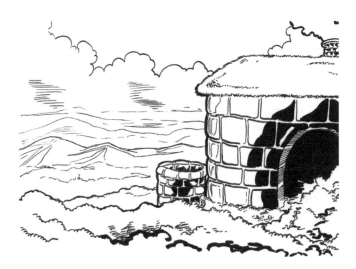

As you can see, we've got a nice little cottage in front of a vast view that goes off into the distance. Now, the house is right in front of us, so the detail is crisper and more defined (we could even expect someone to casually walk out and greet us from some cartoon world). But as we move further back, details get lost, lines come together—in short, things lose definition. If you look outside your window (provided that you live somewhere with some sort of view), you'll see the same effect in actual space: color, light, opacity, and everything else diminishes once you start viewing objects that are farther away. We will be exploring the ways by which we can create the illusion of distance as we go into texture and line weight in design, but for now, let's push on!

Actually, let's go back to you looking out the window for a moment. See how you can view the horizon from there? Now, say you live in a house with two floors, and you are viewing the horizon from the second floor. Run downstairs real quick, and open the door, provided that your front door view also allows you to see the horizon. Go ahead, I'll wait.

Ready?

You might not notice it at first, but you have been viewing the horizon differently from this point (in fact, it may now seem a tad bit higher). Also, look at everything around you. Say, your dad's car is parked outside. Its relation to the horizon has now changed because you have changed your viewing spot. From the window, we could see the car slightly from above, thus implying a different angle and, conversely, a different relation to the horizon line in general. Yet none of the elements have moved or changed—just your vantage point.

You may go back to your room now.

As you can tell by this example, the relation between the horizon and all the elements connected to it is completely dependent on the viewer's *eye level*. If we're standing on the ground, the horizon's impact on all props leading up to it tends to be equal (we are looking straight at it, and only corners and angles make any difference to how things are viewed). However, if we were to lie down on the ground or get on the roof of our house and look at those

same props, the relation is different because we are not on the same level as said props. Let's look at some examples: first, a straight-on view of a house at eye level:

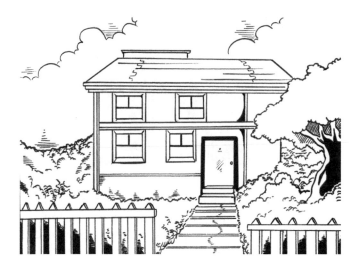

Pretty cut and dry, correct? The house is directly in front of the horizon (in fact, the horizon almost cuts the image in half, doesn't it?). But now, let's look at the same house from a slightly higher angle. Let's pretend we're the front-door neighbors, looking from our second-floor window:

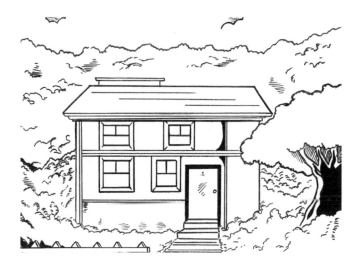

Aha! The horizon moves higher in the frame, because our viewpoint changes!

Before we continue onward with different points concerning layout, one note must be made clear: the horizon is supposed to be the farthest point on a particular plane and the spot at which the viewer's ability to distinguish individual shapes ceases to be. In order for that concept to work, avoid drawing elements that end directly on the horizon if the scene is supposed to have a sense of depth to it because any three-dimensional object on the horizon would still have its own vanishing points and its own dimensions, needing its own horizon. It would immediately imply even more distance, thus killing the original effect. We will explore more elements like this when we go directly into layouts in design. It's just that this turns out to be a common mistake, and I want you to avoid it.

With just these two concepts (the horizon and the eye level), you are already well on your way to illustrating stronger, more dynamic environments for storytelling. However, there is one basic concept we should discuss before we move into the type of layouts that you'll generally produce for visual narratives: the *cone of vision*.

As human beings, we have a limited vantage point by which we can view the world, simply because we only have one point of visual access: our eyes. There is a point at which we lose sight of a particular panorama or shot because we are limited by our optical vantage point, in which case, generally, we would turn our heads or step back to increase said vantage point. The *cone of vision* represents the space around which our eyes can see when focused on a particular point within the horizon. This includes said point of focus (what you are actually looking at) and your peripheral vision (those elements surrounding said focus, stretching to the point where one

can't see). As a quick exercise, stretch your arms out in front of you, as if to point out the horizon. Now, pull them back slowly to your sides, but keep both arms stretched out. There will be a point at which you won't be able to see your outstretched arms any more as they leave your *cone of vision*, thus showing the limit of your point of view.

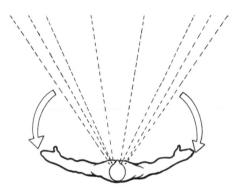

We'll review more specific ways by which the cone of vision is determined in the next couple of segments, but one thing that should be made clear before-hand is that the cone of vision is most closely related to the way an image is laid out in terms of its relation to the established horizon. To do so, we establish *vanishing points* on the horizon, which are the points (or point) by which elements on a particular image measure out toward the horizon (basically establishing the ground and dimensions of a piece). There are various layout types that take into account the relation towards the horizon, which we will be reviewing shortly. They include:

- One-point perspective
- Two-point perspective (along with two-point vertical)
- Three-point perspective
- Four-point and zero-point perspective

Now, don't look so scared. The purpose of this book is to clarify some of these terms, and I'm sure that after these chapters, you'll walk out with new-found confidence in your design skills.

So let's push onward, I say!

ONE-POINT PERSPECTIVE

One-point perspective is the most commonly viewed of the perspective points when dealing with establishing shots, environment studies, or just clear background sketching. We generally relate to it the most, as we tend to observe things in terms of a direct point of view.

An image demonstrating a one-point perspective layout employs one vanishing point on a horizon from which all elements extend and connect. It implies that we are at eye level, looking forward, viewing a full environment that itself stretches back toward just one spot on the horizon. Let's take, for example, a simple box, and place it in one-point perspective, to better understand this concept:

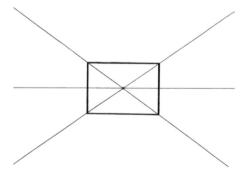

The box basically looks like a square, doesn't it? That's because it is directly in front of the viewer and its layout is connecting to the horizon. Let's move the box around a bit to better see this relation:

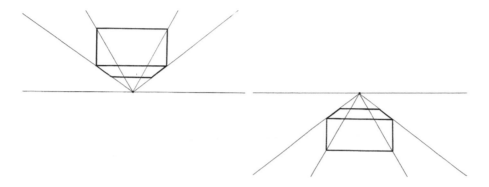

See? The box remains in connection to one point in the horizon, even if the object is above or below the horizon line. Keep in mind that one-point (as well as two-point perspective) is dependent on the viewer's direct relation to the horizon on the notion of the eye level being level, meaning that the image implies we are looking directly towards the horizon. Now, let's add some more elements to our layout, such as more boxes and a road: we're drawing the layout of a street:

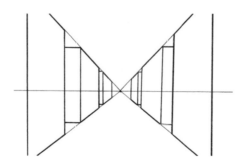

Now, let's drop the horizon a bit, implying we are closer to the ground but still dealing with only one point within it:

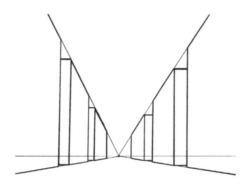

The relation between the very same objects with the horizon changes depending on the placement of the horizon, as well as the way the lines (and the layout) extend from said horizon. In other words, the closer we place our lines from the central vanishing point, the closer we'll be to the ground in the layout.

So, where do we see one-point perspective often? Try a first-person shooter game or watch a film in which you see a character's point of view (POV). Any time we see our hero drive into the sunset on a deserted road, that road tends to be in one-point perspective. One-point perspective offers clarity and a sense of understanding to our surroundings. It can also create a clear focal point for our action and leave us to view the action on the scene unencumbered. (To go back to gaming, classic side-scroller games tend to happen in front of a one-point perspective world. They serve to better present the eternal struggle between the forces of our champion—Player One—versus the opposition—the computer, or a friend playing against you—whom I will not judge because I don't know you that well. I'll leave that to your parents.)

TWO-POINT PERSPECTIVE

So far, we've discussed the horizon, vanishing points, and their relation to objects within layout when being viewed from one-point perspective.

However, even though we live technically in a one-point perspective frame in terms of what we see, we don't necessarily always view objects at the same angle or level, which creates different layouts and possibilities. For example, say we want to present a character (let's call him Happy Face McGillicutty... or Joe) walking down a sidewalk. He's unaware that hiding at a corner at the end of said street, a creepy monster awaits him, ready to do him no good (this is a stereotypical view of monsters, and if there are any such creatures reading this passage, I extend my deepest apologies). Now, armed with our knowledge of one-point perspective, we could lay out the scene in the following fashion:

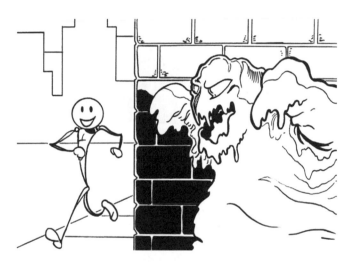

As you can see, we have our scene set, with all the elements needed clearly on display, as our characters prepare to interact. Good, right? Yet there seems to be a limit to what can be said with this flat layout that could perhaps be augmented with a different, more interactive layout. Let's try this scene again, but this time, let's view the scene at a different angle: same

elements (the unwitting sap and the monster), but this time let's view them from an angle on the street, with the man walking on a diagonal angle toward the viewer, and the monster, awaiting his victim, standing at the opposite angle of the street corner:

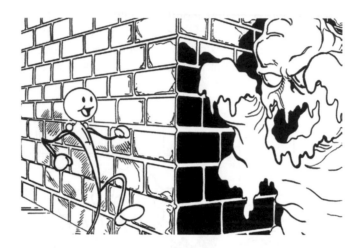

The information and the drama completely change, even though we have the same players and the same elements within our illustration. We have more of a sense of anticipation, and perhaps a bit more dread, caused by presenting a visual beyond the framework of one particular layout grid. In this case, we took into account an angle on the corner, viewing it with the corner itself facing the viewer, instead of just one of its sides. This effect is achieved through the use of two-point perspective.

Two-point perspective implies that there are two vanishing points present, on which one particular object is interacting with the horizon, all of which basically means that we are viewing an object at an angle on a horizontal plane. Take the previously drawn square that interacted with the horizon on a one-point perspective grid. If we make the same square still interact with the eye level, but this time view it with two points extending from the horizon, we now view it with two sides of the square showing, each heading diagonally

into the horizon, creating more of a square feel instead of the flat box placed on the original image:

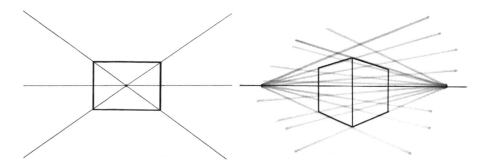

We are still at the same eye level, but we've changed our viewpoint, making the image a bit more three-dimensional or at least implying the illusion of dimensions. Now let's look at the same type of layout, but this time interacting with multiple elements, all viewed at an angle:

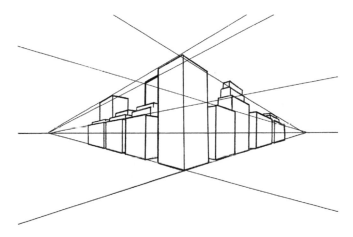

It almost feels like you are turning your head to the side while standing on a street corner, doesn't it? Expanding the possibilities of how we view layouts on a plane can create multiple opportunities for visual drama, which in turn can create more compelling pieces of storytelling. This concept will become even clearer as we continue through the chapters within this book, but let's proceed with two-point perspective, as there are two more points within the subject I would like to cover (pun, unfortunately, intended).

The inclusion of two-point perspective to your layout repertoire decrees that we must once again expand on the cone of vision, if only to help you avoid certain pitfalls that seem to afflict the visual artist. Let's view a scene in two-point perspective of a particular street corner, limited to the framework of your page:

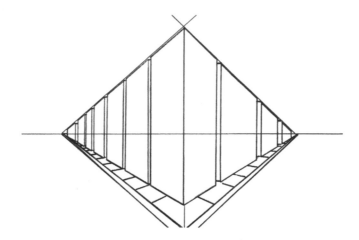

There you have it. A city block framed in one shot using two-point perspective, complete within its implied angle, ready and in full view. Now we can move on to other...

Wait. This doesn't look right, does it?

The problem here is not that the relation to the vanishing points is incorrect (they are represented clearly throughout the design) or that we are employing bad two-point perspective (all elements connect to the two vanishing points established within the layout). Here, the problem lies in the placement of said vanishing points; in this case, they are way too close to one another to truly showcase a concise representation of what one would see at a street corner. These types of visuals can be useful, especially if you are trying to create the illusion of distance in relation to a character in closer proximity (a concept known as *forced perspective*), but in this case, we are trying to create the perception of an actual space in use, with real distance. Walk outside of your house (I know, yet again—bear with me, please), and look at a particular street or alley corner that would be placed on a two-point perspective layout if drawn. If you look carefully, the vanishing points within this framework would extend beyond your cone of vision due to the fact that said cone is not limited to the amount of space you can see but rather the entire plane's relation and interaction with the horizon itself. The same would happen in an illustration: in two-point perspective, your vanishing points will generally extend beyond the scope of your cone of vision within the framework of one shot. To illustrate this further, let's revisit the previous image, this time stretching the vanishing points farther out in the horizon from the actual illustration itself:

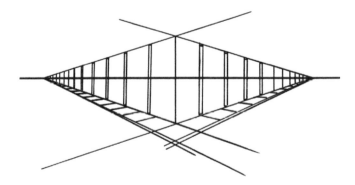

A good rule of thumb is to extend the vanishing points to where two lines connecting from the two different points would meet either beyond or up to a 90-degree angle. If the two points meet at a spot where the bend is less than 90 degrees, your vanishing points are too close together and your image will look warped.

Finally, two-point perspective is useful beyond just the horizontal plane and can help enhance a one-point perspective piece. Say, for example, we have

a shot from above ground that represents one point in the horizon (even if
the horizon itself is not in full view within the scene), but due to the angle at
which we are engaging this particular scene, there are diagonal slants at the
sides of a particular structure, as if implying a second vanishing point under
the image itself. This layout structure would be called a *two-point vertical*,
which is set by drawing a vertical line from the vanishing point preestab-
lished on your horizon and placing a second vanishing point upon it to cre-
ate the slant on the piece. Let's look at our square/box yet again, this time in
a two-point vertical angle:

The box suddenly has even more dimension: we feel as if we are viewing it
from above but still standing right in front of the box and the horizon itself. To
give this point a bit more context, let's transform the box into a building next
to others as we view all of them from above:

It's important to remember that the same way the distance between vanishing points affects two-point perspective when placed horizontally, so does placing vanishing points on a two-point vertical layout. Remember, "90 degrees" is the key: over or at 90 degrees, you tend to be good, but at less than 90 degrees, you tend to leave the cone of vision, and your imagery gets a bit wonky (which, I assure you, is a super-duper technical term). We'll be discussing blocking of scenes as the chapters progress, and we will revisit the cone of vision as well as your placement of vanishing points.

One last word on two-point vertical before we move on: two-point vertical perspective implies that there are no vertical lines in your piece except for the central line created to establish the vanishing points in the first place. However, horizontal lines are still very much present within our grid (it's meant to mimic one-point perspective because the idea is that we are facing the horizon, even though it might not be blocked within the scene). However, if we were to look at a piece in two-point perspective within the context of the horizon alone, and we were to look upward or downward to view our blocked scene (in correlation to the horizon, that is), that would imply a different grid system would be required to represent such a scene. One that would perhaps imply the use of a *third point* outside of the horizon itself. Madness, you say? Read on!

THREE-POINT PERSPECTIVE

Here's where things get interesting. Everything we've discussed so far depends on the notion that we are, in fact, facing the horizon. Yet we have heads—with necks, even—and sometimes we don't face forward to engage our world. No, my friends, sometimes we do something crazy like looking up (gasp) or down (shock!) at something, thus not necessarily having the horizon within our frame of view. Yet the horizon didn't disappear because we aren't necessarily looking at it directly, so every object still has a relation to it, while we also create a third vanishing point in the sky, representing the spot we are actually viewing. And so, fearless champions, we've entered the world of *three-point perspective*, a subject that has garnered groans in almost every classroom I've entered yet is, at its core, a rather simple concept once you get the logistics down.

Three-point perspective implies that the object viewed is at a two-point perspective angle, with two vanishing points leading to the horizon, while creating a third vanishing point either above or below the horizon line. If the

point is placed above the horizon line, it suggests that we are viewing an object from below looking upward (a low-angle shot, in the parlance of film speak), which will make the bottom of said object look much closer to us than the top. (Note that three-point perspective works only if we are viewing an object in a two-point perspective frame and are looking either upward or downward upon it. This means that there will be no vertical or horizontal lines employed because we are viewing an object at an angle; thus we have a dull slant on both sides as well as above and below the object. If we were viewing an object from above or below, but viewing it head on, we might not have vertical lines employed; though we would be dealing with one-point perspective, we would definitely be dealing with horizontal lines throughout, which imply at the very least a two-point vertical angle.) To clarify things even further, let's view a couple of examples: first, our old friend, the box, will be viewed at an angle, floating above as if an anvil is being dropped on us like we're some kind of cartoon coyote or something:

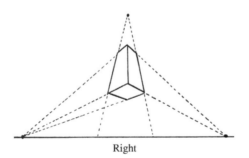

Right

Notice the point above the horizon line, with enough distance from the piece where it complements the angle created by the two points on the horizon itself, thus creating a proper slant to the object. This helps to create the illusion of distance from the "ground" and, more important, the viewer. Also, we can see the bottom of the box itself as we look at the piece from underneath, again creating the illusion of dimensions and space. Now, if we were to illustrate the box, this time looking at it from an angle above the horizon, the same elements would apply (distance, angles, no verticals or horizontals), with the only difference being that we would be viewing these elements with

a vanishing point *below* the horizon, indicating where our new viewpoint would be (a *high-angle shot*):

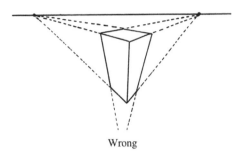

Wrong

See? It's the same concept, but this time with a different effect. Now we see right above the block instead of below, creating a sense of distance yet again, but from a higher altitude to the box itself. It's also important to note at this point that the laws of the cone of vision still apply to three-point perspective, whether seen from above or below the horizon itself. The closer the third vanishing point is to the interconnecting lines from the two other vanishing points created on the horizon, the larger the exposed sector of the object viewed will look (either from above or below), so keep in mind distance and angle when you are illustrating the piece. Also, the 90-degree rule still applies to points at which the lines from said vanishing points meet, for if the angle is too steep, your image will appear jagged and bent and a bit forced. Or, to put it another way:

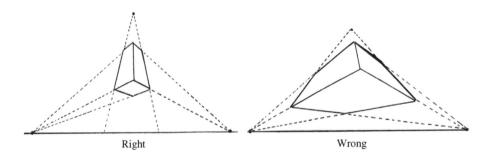

Right Wrong

There. That should clear things up.

But why do we need this stuff, you ask?

The simple answer is that the world is not static, and neither is visual storytelling. In order to create exciting characters and environments, one must understand them from every position and angle, just to get a good sense of design and purpose (we'll be talking a *lot* more about this concept later in the book). The angles we choose within our narrative must serve the desired effect of the visual within the story, so they must be as interesting and dynamic as possible. No matter how much those old side-scroller Nintendo games would like us to believe that the world is a straight-forward line where we meet our challenges head on (or side-scrolled, if we're going to beat the metaphor into the ground), we constantly engage elements both bigger and smaller than us, and each represents something different to the viewer when used correctly. Take, for example, the following shot:

A low angle, placed in three points, can add a dramatic element to a particular scene. It makes the character seem larger, more imposing, and even regal. Now look at the background: the environment surrounds the character and complements it, showcasing the power of the scene. Now let's look at an opposing angle:

Here we have a character looking upward at something imposing, but this time we're viewing reaction and a comparison point. In this shot, our character looks miniscule, even weak, with the background complementing the shot. It feels as if the viewer is looking down upon the scene, putting the showcased character in the visual stance of disadvantage. Already, with your choice of shot angle, you are saying tons about the character's situation and mindset, and not a word has been spoken yet.

Truth be told, there is a point to every single decision involving environment and layout in terms of story structure and design (whether it's a conscious decision or a subconscious one is left to the artist). All perspective layout designs are meant to enhance the information showcased within each illustration to better serve a linear narrative. Whether you are viewing one illustration or one of many panels in a comic, each angle presented has bearing on the scene it establishes, and each scene builds up to a full story. With one-point, two-point, and three-point perspective, we have the basic working tools to begin your study into interactive environments for storytelling—and there are yet more options to cover. Ready?

FOUR-POINT AND ZERO-POINT PERSPECTIVE

In most classrooms, the biggest concern is usually to get people to understand one-point, two-point, and three-point perspective layouts, as they are the ones that most people would encounter in their regular daily lives. Most people tend to comprehend the concepts they can relate to most closely the quickest. We will eventually, at some point during our day, encounter something head

on, at an angle, or look up and down once in a while. This is why these next two layouts might be new to you, but as you'll see, they are just as relatable and common as the previous, more familiar perspective setups.

Four-point perspective, for example, uses the same structure of three-point perspective, but instead of just dealing with something that's either above or below the horizon line, it instead represents a scene, at an angle, in which we are viewing an object with the horizon in plain view but also employing two more vanishing points, one above and below the horizon. Once again, let's revisit our friend the box, this time placing it in a layout that employs four-point perspective:

Seems familiar, doesn't it? If you've ever looked through a peephole on an apartment door, or gone to a funhouse and looked at yourself in the warped mirrors, you'll recognize the framework. It's essentially anything either viewed or placed on a bent or folded angle (or viewed through a *fish-eye lens*) across a particular horizon. Some of this perspective's uses in films or in animation include either warping the imagery while making the audience member feel uneasy, to demonstrate a view through a warped lens or glass, or to represent a reflection on a bent surface. To clarify even further, let's look at an establishing shot of a street corner in two views. The first illustration will be a two-point perspective piece:

Simple enough, I think. Now let's take this same image and convert it to a four-point perspective layout and see the results:

Trippy, am I right? You might be surprised by how often this type of layout is used, not only in movies and animated features but also in both modern and classical animation as well as gaming levels in which players are meant to proceed when their environment might be warping against them. Still, creating these images and keeping them consistent throughout might be a bit difficult for the newer or inexperienced artist. So it might not be a bad idea to build and develop multiple perspective grids for continuous use. A *perspective grid* is basically a floor map that establishes a clear horizontal line, a vanishing point (or multiple ones), and all the lines that might be established from said points within a particular layout. These can be built and used to map out the specific locations of any elements within an environment while keeping them tied within the established perspective layout throughout the piece. To illustrate this point, let's create two grids, one for a two-point perspective piece and one for a four-point perspective piece (as both these layouts have been featured in this section, I figured we'd stay current):

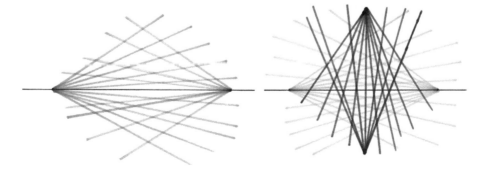

Using both grids, let's draw two boxes, with one drawn in the two-point perspective grid, and the other drawn in the four-point perspective grid:

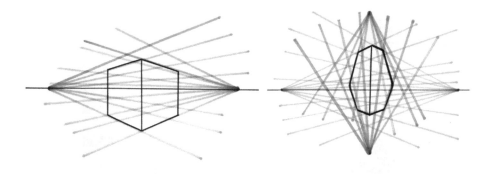

As you can see, the use of the grid system actually increases the opportunities within each layout for placement and accuracy in the space allotted for an illustration. Building multiple grids for you can be extremely useful when developing environment scenes, and they can be easily used with a light box or even a tracing paper overlay to create an illustration. Many artists have found it even easier to create personalized grids digitally and keep them as a separate layer within their project files to line up their work when working on a digital pen tablet. However you choose to apply them, they are a helpful tool within your now-growing artistic arsenal (which, if you're on the dorky side like me, sounds pretty cool).

One layout design in which grids might not be so helpful is *zero-point perspective*, and this is because... well, just read the name: *zero point*. When dealing with this type of layout, we are actually designing an environment that either (a) doesn't have a horizon present (or even existent) or (b) has a horizon, but the relation between objects and the horizon is not linear or direct. The first one is a bit easier to explain: it's space, or the sky, or any environment where there is no ground and also little to no atmosphere. The idea is that objects are free-floating in their placement within a scene in which objects do not relate to one particular horizon or to each other.

For example, let's view an illustration of a spaceship, midflight, going through an asteroid field:

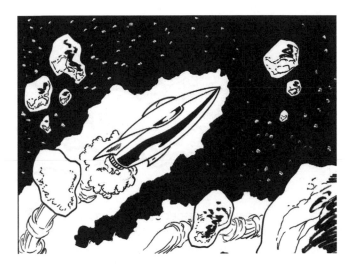

This is not to say that the ship doesn't have a perspective within itself; if you drew lines from the ship's various elements into the background, chances are good that the ship itself would have a vanishing point at which all elements converge. However, the rocks and asteroids floating around it would not necessarily have layout lines that would extend to the same vanishing point; rather, they would each have a vanishing point of their own, in a horizon all their own. Thus, zero-point perspective doesn't so much negate the existence of a horizon but rather implies that each element, floating freely, has a horizon of its own.

Then there is point B: a layout in which the horizon is visible but not all elements connect or have vanishing points leading to said horizon. Such a layout often depicts rural areas, forests, jungles, or any environments in which the ground is not a completely flat surface and organic life grows freely, without any particular structural alignment.

Well, there you go. Zero-point perspective is overly used within the media arts, considering how much of the genres covered within most visual storytelling venues are related to science fiction, adventure, or horror. From television's *Star Wars: The Clone Wars* to the *Uncharted* series of games and even scary stuff like *Hellboy* as well as any ghost story involving free-floating spirits and objects, zero-point perspective is used almost as much as, if not more than, other established layout designs. All of these grids are meant to complement one another and enable you to tell exciting, dynamic stories outside of one flat, continuous environment shot. Even though "the world is a stage," as some dead guy once said, we are not limited to the classic stage area, all boxed in to one shot, to tell our stories.

A couple of points before we move on to the next chapter. First, I do not want you to think of this set of environmental layouts as the entire spectrum of layout types available to assist the modern artist. Far from it, actually; there are five-, six-, and even seven-point perspectives (and even more beyond that) ready for further exploration. The layouts discussed in this chapter take into account that we are viewing an environment in a *Cartesian*, or flat, scene. The *Cartesian* coordinate system allows for measurement units to be placed on top of a flat or linear surface, which is how we create vanishing points (there are actual equations for each one of these environment grids, but I teach them in terms of context that students can relate to, and I hope that my explanations have been clear). However, if we expand our view to take into account the curvature of the earth or different angles to

any particular plane, multiple perspective layouts can be used at once, thus allowing more complicated grid systems. In these pages, I've included the layout choices most used in the realms of film, animation, sequential art, as well as game design, and within those contexts you should be more than ready to begin the process of layout exploration.

The second point before we move on is that no grid system, breakdown of boxes, spatial relations, or study of mass and depth can work without one critical element: *your artistic eye*. Understanding the implications of spatial relations is extremely important in terms of implementing visual elements throughout a particular scene. Therefore, you have to see in three dimensions—not just in your world, but on paper as well. The tools, tricks, or concepts covered here and in future sections will help you to represent those notions. However, we must first agree that as artists, we must also steer the fantasy worlds we create on paper to some sense of reality so that the viewer can relate to the absurdity of the story itself (what film critics call "suspension of disbelief"). Every bit helps, and that includes your understanding of environment design. So take the concepts covered within, practice them, and hone your skills, because you will need them throughout this process. Soon, they will become second nature, to the extent that you'll be able to visualize your space without all the layout requirements presented here. But we still have some ground to cover before you get to that point.

In short, we're just getting started.

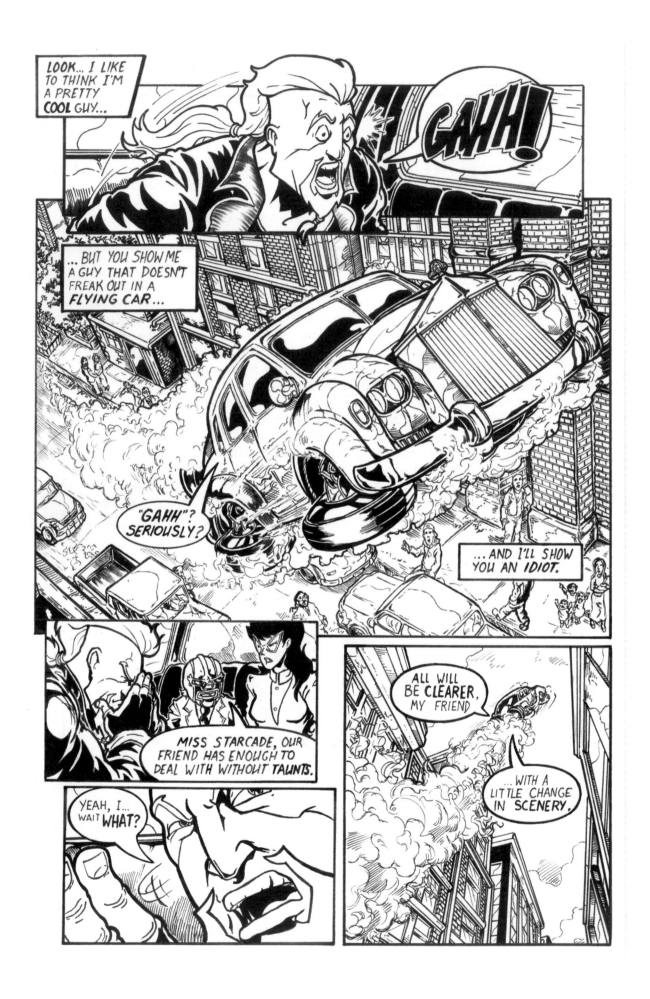

Section 2

Laying Out the Action!

Flying cars! The future is here!

You may have noticed that there is a concurrent narrative going through these chapters, one that's meant to entertain, yes, but also to make a point: that staging and layout are just as important to the flow of the story as the characters within it, and that all these elements are crucial for a proper story to be told, no matter the visual medium.

Storytelling is not just the expression of a set of events occurring in a linear narrative. No, indeed! Storytelling is drama! Action! Danger! Humor! It is all these things *and more!*

Actually, a good story is only as good as the storyteller, so we must learn to use the tools available to us in order to really create something that a reader/viewer/player will want to return to and enjoy over and over.

And yes, this includes backgrounds. In the previous chapter, you learned how to set up a layout and how to create multiple grids for the purpose of visual

storytelling. Now it's time to start populating our worlds, add stakes to the action, and really focus our visuals toward exciting action pieces and terrifying sights.

So let's get to it, then! These shots aren't going to draw themselves, now, are they?

LAYOUTS AS STORYTELLING

As this book is not focused just on background design but rather on background design aimed toward storytelling, I thought it would be best to take this section and, just as we studied our layout grids to better set up our environments, take the time to set up the building blocks of visual storytelling to start understanding how to better connect these layouts with narratives. In doing so, I hope you get a better sense of purpose in terms of the layouts presented previously and have a sense of confidence when applying them within your work.

Before we jump into the subject of storytelling with layouts, however, let's go over some of the fundamentals of *visual* (or for that matter, all forms of) *storytelling*. To do so, I'm going to make some assumptions about you and say that, at some point in your life, you've experienced (either through reading, watching on TV/film, or through the evolving narrative of a game) at least one story. There are many different types of stories—some scary, some funny, some tragic—yet all of them have a similar purpose and structure, which makes them understandable and relatable to their audience. Therefore, a lot of the following will definitely be familiar to you, even if you don't know these concepts by name.

First of all, it is important to know that all storytelling derives from *conflict*, which is a specific issue or concern that provokes the entire action of a story to take place. Basically, it's a motivation that causes your main character to react to the world and either set things right within his/her world, or change his surroundings and his/her status quo. In superhero stories, for example, those conflicts are usually expressed physically (bad guy shows up, does something bad, hero hears about said bad thing, hero engages bad guy to stop bad thing). These are called *external conflicts*. There is also a different type of conflict that is called an *internal conflict*, which is more of a personal, philosophical concept, and it could motivate your character beyond the physical issue presented in the story (usually it's traumatic or concerns a situation the character either has trouble overcoming or uses his/her new role in society to try to remedy).

Well, I can hear you chiming in from the back, looking all frustrated, saying "Okay—we were doing well, just learning about layouts and horizon lines and all that crazy stuff and then you got all English Lit on us! What gives?!" Allow me to explain:

In every good story, the environment speaks directly to the concerns and issues of a particular character. Take the following scene, for example:

Here's a shot of a city (any city, really) during what probably is the earlier hours of the morning (what we would call an *establishing shot*, a visual that sets up your stage for action; we will discuss different shots and go more into depths with them in the blocking chapter). The scene is tranquil and serene, but it already implies certain issues that would connect with any person living in a city: you have to get up, get ready to go to work or school, deal with the people you see daily (some you look forward to seeing, some you don't), traffic congestion, and the list could go on and on and on. Well, those are daily conflicts things we have to do to make a living and, most of all, live. However, they still are relatable and act as an entrance point to your

audience member. Now, let's take these same types of surroundings but add the type of drama we would see in one of these crazy comic stories:

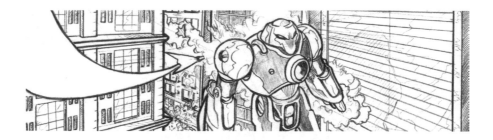

Same type of situation (we are still in a city), but now the environment means something different: this is a city, so there are people all over the place (potential victims), buildings that could be destroyed (which could create obstacles for our hero, or become dangerous for the innocents below), and the environment itself stops being just a familiar place becoming instead a place filled with danger and excitement. Therefore, the environment reacts to the conflict presented, thus enhancing its dramatic effect!

Pretty cool, right? Ah, but there's more!

Going back to storytelling structure, every kid in the world knows that there are three parts to a story: a beginning, a middle, and an end. Well, because we can't just leave things be and just go with what works for us as children, we've taken to naming this set up as the *three-act structure of story-telling*. Here is a quick overview of how the three acts work.

Act 1:

- Establishes our main character (or characters), and the world in which our story takes place.
- Inciting incident: the situation that actually changes your character's current situation and establishes the central conflict (or conflicts) of this story.
- Based on the inciting incident, your character (or, again, characters) make a decision on a course of action that responds to the new *status quo* (this is normally called the *call* in fiction) and begins the process of implementing said course.

Act 2:

- Our characters begin to have their first real tests and victories in terms of their new course of action as they explore their world more closely, meeting allies and enemies alike.
- The opposition redoubles their efforts, and weaknesses/threats are discovered that might threaten the success of our character's (or characters') mission.
- This all leads to what is called a *moment of crisis*, or the lowest point of our protagonists' endeavor. Basically, the opposition has the advantage, threats have been exploited, and a momentous decision must be made in order for our characters to advance toward a final confrontation/resolution.

Act 3:

- The decision made in Act 2 becomes a new call to arms, as our protagonist(s) prepare for a final showdown with the opposition (thus confronting the central conflict within the story). This will lead directly to...
- ... the climax! This is the moment we've been waiting for since the beginning of the story, straight from Act 1! From here, we get to finish our story with...
- ... the resolution, or how our story leaves off. It could be with everything set right in the world and your characters living happily ever after, or it could end in complete tears, or it could end with the promise of even more adventures (as potentially profitable enterprises tend to do).

This is more or less the basic three-act structure of storytelling. Oh, there's plenty more to it, and if you study your Joseph Campbell, you'll find that this very simple structure can open the door to very complex levels of epic narrative, but for now, this version serves our purpose.

We've begun with the premise that backgrounds are essentially the stage on which storytelling takes place. Also, the environment speaks to the emotional impact of a character's stake within a particular story. Now we get to view the environment as an intrinsic part of the story, one that moves the narrative along and affects its overall outcomes.

Let's start with Act 1. Let's say the following image represents our status quo, once again using an establishing shot:

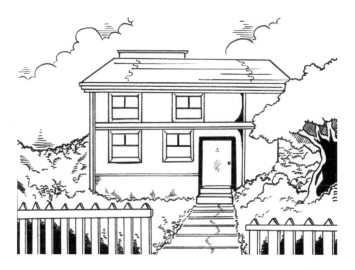

This is what you would call a relatable status quo (though, to be honest, it's plenty idealized). The idea here would be to start with something close to normal, something that the audience member can relate to, so that, when the change in the status quo occurs, this most ideal of settings will acquire a different meaning. Let's say, for example, that our inciting incident is going to be, oh, I don't know, alligator people take over the world.

At the end of Act 1, our environment might look something like this:

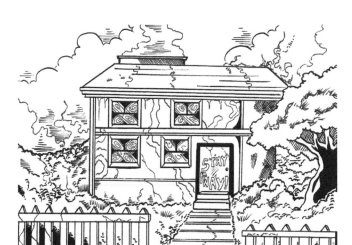

Drama! We now have the exact same environment, but it's now completely changed to serve the necessity of the story. Our stage reacts the same as our character reacts, and it informs the character on what he/she must now do.

Next, Act 2: the house has become the last stronghold of humanity. Alligator people are slowly taking over the world, but not this house, by gum! Thus, our setting changes yet again:

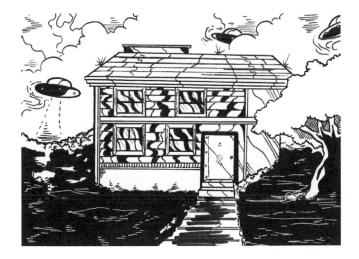

Our location is now fitting for the purpose of defense and offense, yet remains the same place. The narrative makes the environment organic and reactive. It also, apparently, makes it cool!

Finally, let's move on to Act 3 and our finale: shortly after the discovery of a rebel alliance within the alligator people that allows for the dethroning of the evil Lord Arsvardsdus (whatever... I'm not good with names), peace is finally reached, leaving us to return to the scene, now years later, and find this:

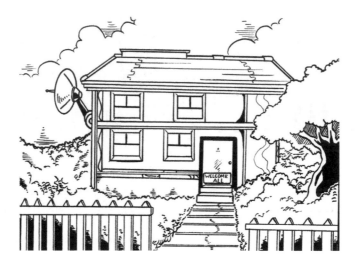

We've rebuilt and restored the status quo, while at the same time acknowledging the changes that have occurred within our narrative. Just as our characters grow as people and begin to behave in accordance to what they have experienced, so do our environments, because they are characters in the story as well!

Throughout this section, we'll explore other ways in which layouts respond to storytelling, and give you multiple options as to how best to represent a particular scene and how to use the environment to enhance it. Keep in mind that there are no rules that can't be broken and that this book is not meant to be the definitive word on environmental storytelling. This book's ultimate purpose is to prepare you with the knowledge necessary to let you decide how to use your environments in a way that best showcases your narrative.

In short, I'm not here to tell you how to tell a story or what to tell. That, my friend, is completely up to you. Onward!

KEY PROPS AND SCALE

Another key component of visual storytelling that affects the overall experience of the viewer is *interactivity*, or the viewer's ability to connect with the world in which our story takes place. It can be a *direct interactivity* (as in games, where we move around a particular world as we ourselves evolve the story through our actions), *indirect interactivity* (where we connect mostly visually, as we watch a story unfold within a world that although we can't control it, we can very well identify with it, which happens when we watch films and plays), or a combination of the two (in comics, for example, the action is set up on paper, so you read it and view it like a movie, but you also control the pace at which you read and the information that is inferred between panels, which makes you invest into the story a bit more personally). In all its forms, however, they must reflect a world that may not be exactly the same as ours (and, in some cases, completely different than ours) but reflects rules and concepts that make it a world we can accept and enjoy.

Which brings us back to our old friends, the perspective grids.

We've explored how to lay out a particular scene viewed from various vantage points to create the illusion of a working horizon connected to the rest of a plane. However, all elements extending from that horizon must also interact with it in one way or another, correct? So how do we establish props and elements along a particular plane and have them make sense visually?

Well, let's start with what you know: let's draw out a one-point perspective grid, with a clearly defined vanishing point smack dab in the center:

Next, let's extend two lines from the vanishing point, both in the same direction, with one establishing a line on the ground going straight back to the horizon, and the other lined above it:

Now, within those lines, in a part of the grid that is closer to us, we are going to draw the figure of a man (or rather the shape of one, in cylindrical or blocked out shapes, very basic stuff). This man will represent a figure that is closer within the scene, and will begin the process of scaling it:

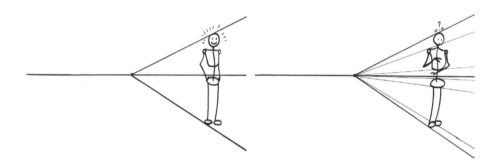

Thanks to this very basic figure, we now have a concept of space within our design that we didn't have before. We've established dimensions within the piece by setting up a direct relationship with the plane, objects on said plane, and the horizon in a recognizable way. We can illustrate this relationship even further by using the lines we've already established from the horizon to cement our figure's spot on the ground and, by adding lines connecting every key joint or bend on the figure to the horizon, we can draw out multiple figures extending all the way back to the vanishing point.

Here, we see and understand a full relationship between a figure and its environment in a linear fashion:

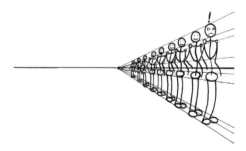

Weird, right? And, hey, if you want to see something else that's cool, draw a horizontal line from the top of the figure's head as well as the bottom, and also the same extremities used to line up the mannequin army to the horizon.

Now, shooting different lines from the vanishing point (still using the same level for floor and head, but now at a different angle), you can create multiple versions of "box dude," each one with figures extending all the way to the background:

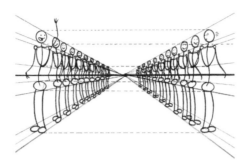

All these examples and layouts extend from one key point: that first boxed figure drawn on the plane. Using this one character, we've been able to place multiple characters within the scene, filling up the space adequately. Thus, our first box figure becomes a *key prop* within our image, an object or figure drawn in a relative space within a layout to establish dimensions on a particular plane or environment.

Usually a key prop is something we recognize readily and is present in the forefront of a particular scene. For example:

If we look at the foreground here, we can see different elements (lamp posts, doorframes, or even people) from where we can create a direct line to the horizon and with it set up a clear plane where characters can stand. However, obviously, not everyone is standing at the same height (it would be weird if they were).

Unless we're dealing with a world of clones, where the symmetry is supposed to be creepy, any representation of a populated world needs to deal with the fact that we are all different. You are a unique snowflake, I guess.

Let's look at our main players in our concurrent narrative as an example:

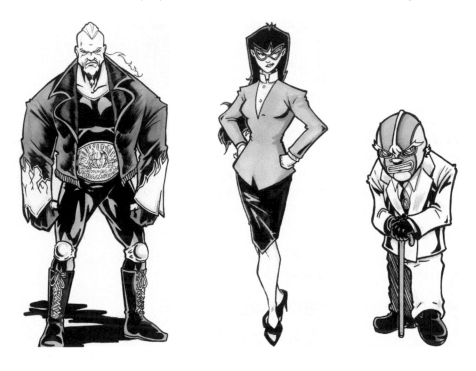

Our hero, Felix Fahrenheit, is supposed to be a big lug, with wide shoulders and a large frame. Next to him, Stacy Starcade, a woman who is supposed to be of average height for a young woman, looks relatively shorter. The Silver Champion, a smaller character, is supposed to look unassuming and weird, dwarfed by even the average-sized Starcade. All these characters are

expected to relate to one another within a plane, but also remain in their proper size and shape:

What helps to create this imagery is the concept of *ratio*. Ratio is basically the idea of setting up a measurement by which props, building structures, and characters can be placed in a context in which an audience member will understand height and shape differences. We just did this by comparing heights within our central cast, but we don't just need characters to make ratio work. In fact, our key props can help make this concept even clearer.

Let's look at another example:

Here's another city shot, but this time we're focusing on how to best show-case height and size ratios. In this particular image, the big, helpful piece is the doorframe. Why? Because we *all* have dealt with and gone through a doorframe, and we all understand that there is a certain height to it that relates to a normal person. Here's another door, but in a different shot:

Here, the relation with the door means something different to the audience member, simply because of the way it's used. In the previous illustration, the point of the image is to show a relatable world to place our character within. Now, the idea is to showcase how much bigger than life our character is because of how huge he is in relation to the door, thus impressing the audience member... because, again, we've all seen, gone through, and opened a door!

With this very quick connection, the storytelling becomes even richer! Now, all the props that are added to a scene are meant, in one way or another, to affect and progress the storytelling. Any gamer will tell you that any stage or level of any game is meant not just as scenery but also as spaces and

structures to be used and exploited within a game. Movies also go down this road, with action films constantly establishing props or layouts that in later scenes become things you use to hit someone, help you escape something, or simply blow the heck up! Let's look at the following layout, first as a simple grid:

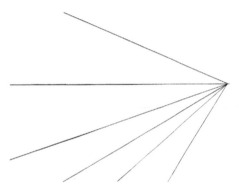

Let's fill up the grid and get some placeholders to prepare for a usable environment:

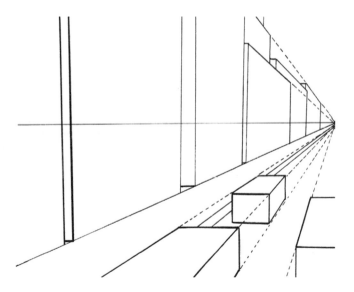

Next, let's actually get this environment rolling! Add the features that will make this an actual, usable scene:

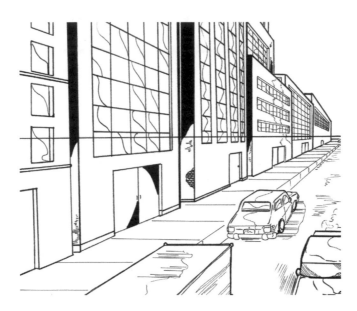

Finally, let's pick a spot that we actually want to use to tell what our scene is going to be, using what we have around us to push the story forward:

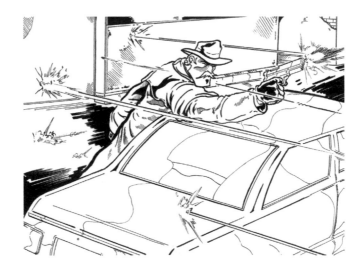

Nice! The environment goes from being just a surrounding to actually having an impact storywise, protecting our character (behind the car) while also being affected by changes around it due to the actions in the story (the bullets hitting the buildings).

The way we're using the environment here is not too different from the general use of background comps in animation, in which the environment is drawn as a separate animation cell and characters are placed on top, very much as players in a play. In comics, on the other hand, the environments and the artwork are not only drawn simultaneously but are also shown in various angles and corners as the panels progress, imitating different camera views or eye levels. In both mediums, however, the way we use the environment, the space, and the props within the space goes beyond just the environmental illustration; it actually goes into the *fluidity of the narrative*, making the environment not only more expressive but exciting as well.

We've now covered dimensions, depth, and space. Next, we're going to really get these concepts rolling and finding even more ways to make the action feel as "in your face" as possible. All the pieces are starting to come together, but we still have a lot to do!

LINE WEIGHT IN DIMENSIONS

Have you ever had an experience, either playing a game or watching a film, in which you felt that you were completely immersed in the action, to the point that you felt surrounded by it? Oh, and I'm not talking about a 3D-produced experience, where the immersion is artificial. I'm talking about those moments where everything feels like it's a "life or death" situation and you can't turn away or else you'll miss the one second that's going to flip everything you are watching way the heck over! Think Luke trying to destroy the Death Star, Batman soaring toward Arkham City, or Tarzan sliding through a cartoon jungle. Yeah, you know the moment.

Well, the reason the action feels so real is due to the use of our old friends depth and dimension, this time taken to dramatic extremes.

All these components also apply to action shots on paper or on printed media, such as illustrations and comics. Take the next image as an example:

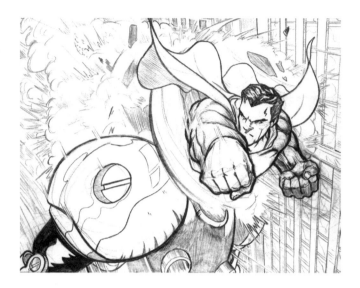

Ka-BOOM!

The force of the piece makes the hit through the robot seem stronger, plus we have a nice sense of distance as well as space between the action hero and the exploding robot. Yet one of the elements that really brings this piece together is not just the image of the hero flying but also the feeling that the fist is flying at us and that there is an actual, speeding body connected right behind it. The reason for this is, yes, dimension, but also the addition of *line weight*.

There's this bad misconception that all that line weight involves is a strong outer line on a figure drawing in a scene, a bit like the lines you tend to find in coloring books. Though cartooning does at times use elements of this structure (commonly referred to as a "dead line" for its uniform, static line throughout) they also use elements of both light and shadow, along with color, to create the illusion of mass. Full illustration and layout design uses line weight in a more intricate manner, taking account of the fact that lighting will be only implied on paper, thus leaving the task of creating depth, mood, and space, in a large part, to the line weight itself.

Basically, what line weight does is it creates the illusion of lighting on paper, with stronger, darker lines on the areas that are supposed to be lit the least, while thinner, less detailed lines are used in areas that are in the presence of a stronger light sources. To illustrate this point, we turn our attention to our old friend Felix Fahrenheit to show examples of different lighting/line weight options:

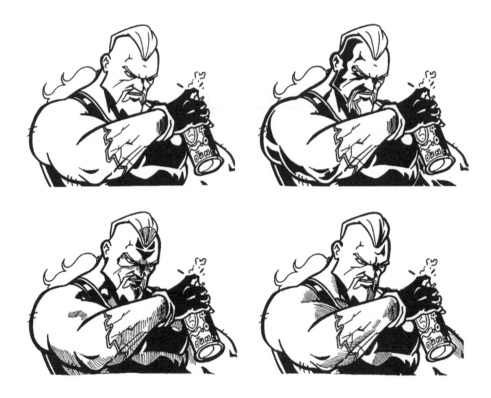

Line weight can also represent the full mass of a character and can create the illusion of joints, slim spots, and thicker tones throughout by differentiating the actual weight and size of the lines used, even if it's on a fluid surface:

See? The jacket feels like it hangs over the body, and the spots where joints meet become thicker as they move out and thinner at the points of connection:

Notice the folds on the jacket, serving as joints of a sort; the lines connecting right at their corners do get thinner, and they expand as they become longer throughout the sleeve. Yet there's a nice contour to the outside line of the arm, tying it all together.

Now, suppose we add a bit of movement to the character (say, by putting Mr. Fahrenheit's arms in front of his chest, as if blocking):

The idea, of course is to create the feeling that there is a full body behind those arms, even if those arms are only line on a piece of paper:

How does this relate to environments? Well, for starters, think of a big ol' explosion:

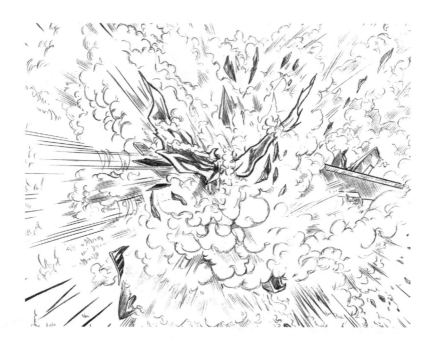

A scene should make you feel as if your senses are being affected by the visuals. When viewing something like this, in which the action is supposed to feel like it's getting closer, line weight adds a level of proximity to a piece or structure, while foreshortening that element of mass and substance behind. Let's look at an image that uses elements of distance, line weight, and mass to create a feeling of focus and power:

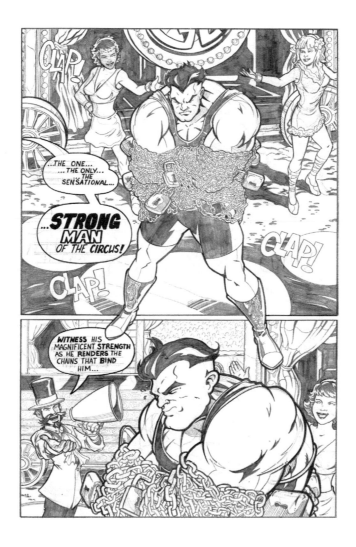

Here we have a strongman character wrapped in chains, with the background showcasing the character. He's farther into the foreground, so his figure has the most line weight and substance (it also has the most details and texture, but we'll discuss that in other chapters). Behind him, the female characters stand in decent detail, but their line weight lessens in comparison with the Strongman. In the second panel, we see the Strongman, still struggling, with the circus trainer in the background, in a lighter line weight. As we go even farther within the scene, we can see the crowd of spectators,

now visible as faraway shapes, with minimal line weight indicating their spot in the environmental plane. The variation of lines (from thick and detailed, to thin and undefined) creates distance and focus on the scene, helping to cement the mood of the piece.

Now, let's take a look at this next scene:

Much like the explosion from earlier, we now have action that reaches toward us and adds a sense of dimension to the piece. Also, because we understand that these pieces are meant to look as if they are approaching us, we've become even closer to the storytelling, as we grasp the context of space between the character and us. This concept is called *foreshortening*, and it works best when one thinks of each feature on the body as boxed-out shapes (or cylindrical shapes) creating a sort of skeleton for our character (the way we established during our previous section, setting up a figure as a key prop from the horizon).

A final note on spatial relations and line weight before we move on: we've spent quite a bit of time discussing perspective grids and layouts in open spaces, but we haven't examined how to create a working environment within closed spots. It's not that different from what we've covered so far; it relates completely to dimensions and depth, as we've got to take into account the spot at which our walls end and fit figures within them.

First, let's start with a simple one-point perspective grid:

Next, let's draw our old friend the square right at the center of the grid (this will serve as our back wall, and the lines extending from it will serve as our roof and walls):

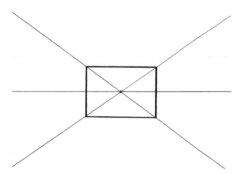

Please note that although the bottom of our room is the bottom of the square, that is not, in fact, your horizon; creating a room implies that we've built an area that is blocked off from the horizon but does have a horizon line in use and still extends from it.

Now, the same rules apply: anything you place closer to us in this room will have stronger line weight, and anything that is farther away will have a lighter line weight:

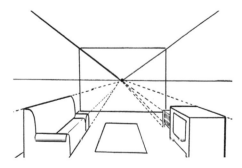

Also, in the same way that we established the effect of lighting with Felix's face, a different light source affects how the room is rendered, along with any furniture within it:

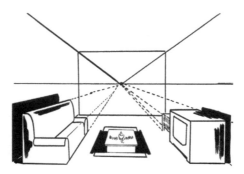

Cool! We've got depth, dimension, and proximity covered. You pretty much know how to set up a shot. Now, all we need to do is to start figuring out the best ways to showcase these shots!

BLOCKING THE ACTION

We've talked about laying out a scene. We've talked about texture, space, and mass in environments. In short, we've talked about a lot of design elements and concepts that are meant to be implemented into visual storytelling.

But implemented how?

Let's begin by reiterating a statement made earlier in this section, and hold it down as law: the *story* is the key! Every element within a narrative reacts to that particular story and serves to enhance the experience.

Well, if we're applying this to background design, then it becomes imperative that we choose the correct angles and layouts to represent accurately the emotion that is meant to be evoked in a particular scene. This process is called *blocking* the action, and although it's generally thought of as a staging or filming process, it applies to all forms of visual storytelling, and is in fact pretty much what we've been doing throughout this book (you just didn't know it!)

Though all our chapters have included an ongoing story (do you think Fahrenheit's landed yet?), let's look at a short narrative as an additional example of blocking for storytelling. The following images show a couple of pages

of a book I worked on for Kaiser Studio Productions called *The Solution*; you don't need to know any backstory to understand the subject, however, so we can focus on each one within the context of the narrative at hand:

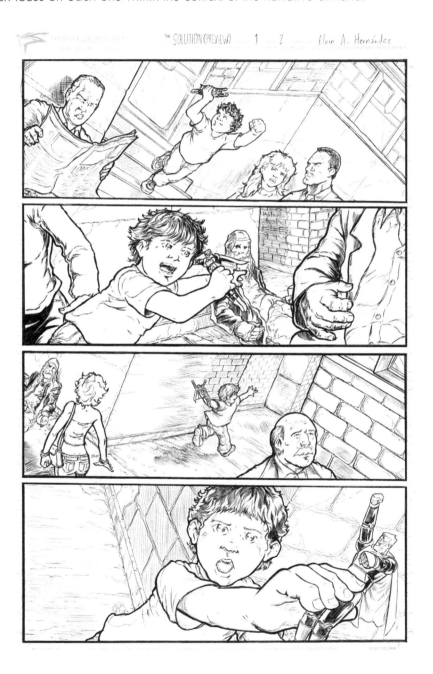

This is only part of a short story, but already we can see a fluid bit of narrative going through the page, with each panel developing the action further. The point here, though, is to understand not only why the story works in a linear fashion but also how the environment and layout helps to further the story along. This means that all the elements we've talked about already in this and the previous chapter need to work together with synergy, and they must do so almost transparently.

Let's start with the first panel:

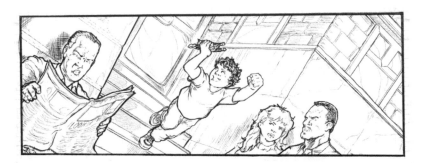

So we have a kid emerging from his apartment, looking happy. Below him, at a different level, people walk the streets, oblivious of the child. The focus is, of course, the kid, and he is framed pretty much center stage on the scene, with his environment complementing the figure. This is what would be called, in the language of film and animation, a *full shot*, as we see the character in full, and the focus is not the environment.

Now, on to the next panel:

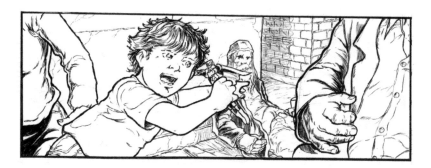

We are now closer to the action, with our kid still playing at superhero stuff and people still walking all around him. We are viewing the action at eye level, meaning that the viewer is at the same level as the action not above or below it; thus we feel connected to the action not just as a spectator but also as part of the experience (we are one in the crowd, so to speak, walking along with the boy). The shot also establishes some elements that will be used in future panels, such as the alleyway and the bum sitting in the corner (poor guy).

In future chapters, we discuss authenticity in design, but keep this in mind: all these features require an understanding of texture, layout, and blocking to trick the viewer into a sense of security and suspension of disbelief. Basically, you have to get the viewer to forget, for a little while, that they are looking at an illustration.

Remember our lessons in key props and dimensions? Here they come into play as well: our kid runs in the foreground, viewed from the torso upward, while everyone else has more of their figure in full view (because we are dealing with adults' versus a kid's eye level). The kid is our key prop, placed in direct relation to the horizon, and all other figures are measured around his placement. He is also in mid-shot, or a medium shot, where his body is not in full view, but the character's torso definitely is. This setup brings us closer to the action without making the scene too personal.

Next panel:

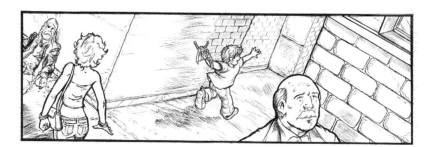

The viewpoint now changes from an eye-level shot to one that goes above ground (either a three-point perspective or two-point vertical piece). This type of shot is generally called a high-angle shot, which places us above the action and lets us see the pieces a bit more arbitrarily (sort of like viewing

chess pieces on a board, in a way). Here we see the kid running down the alley, oblivious to his surroundings as they get darker. Also, notice the bum sitting at the corner within the illustration. You may not realize this, but that bum actually is vital to the flow of the action between these past two panels, as he sets up another concept that is a key component of any visual narrative: *timing*! Timing creates a sense of pace by which we can follow a story. In this case, the poor bum sitting in the corner establishes how long it takes the kid to go from running in the street to running into the alley and beyond.

Now, onto the final panel on the page:

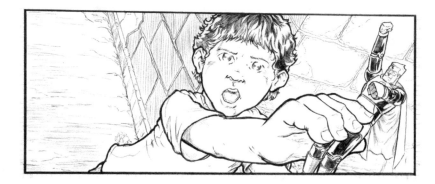

Shock! Awe! Gasps!

Our kid, with a look of amazement and fear, stops in his tracks and stares forward, leaving the world behind. This is shown close to his body, with his hand reaching outward while still holding the toy (a good example of both foreshortening and the use of line weight in a set piece) and creates a sense of proximity to our character, letting us share in the anticipation and making us feel closer to the action from an emotional state. We call this a *medium close-up shot*, which still leaves a bit of the body in view but gets you closer to it to make any situation more intimate.

In order to understand some of these shots a bit more intricately, let's break down some of the basic eye-level views with our old comrade, Felix Fahrenheit:

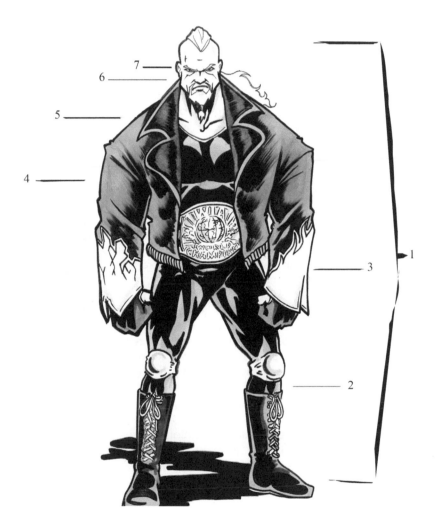

1. *Full Shot:* The body is in full view, and the whole of the character is part of the storytelling.
2. *"American" or "cowboy" shot:* Shot a bit below or right at knee level upward, showcasing a character's physique (also known as a "hero"

shot; gets its two names from the American Western films that first developed it).

3. *Medium Shot*: Shot established at mid level of a focused character, bringing the action closer while not yet reaching the point where the character's personal bubble is being intruded upon. Used in conversation pieces or action shots.

4. *TT or Bust Shot:* (Oh, don't look at me like that! I swear that's what it's called!) This shot goes from right below the bust line or right at the cleavage. Yes, it's used to showcase certain attributes, but it's also used generally on characters that wear emblems or important chest pieces (medals, tattoos, etc.), and it gets you closer to the situation or to the character.

5. *Medium Close-Up*: Also known as a "shoulder" shot, these shots actually focus on proximity, making you feel as if we're invading the character's personal space and making the situation more intimate. Here we are at shoulder level with the character, still not completely in the character's face.

6. *Close-Up*: Now we're in the character's face. We focus on the character's expression and facial features, and the situation is definitely focused on character's reaction and mood. You may think we are as close as it gets, but there's actually one more type of shot that gets even more personal.

7. *Extreme Close-Up*: Focusing on a facial feature (mouth, eye, or nose), we are now as intimate as it's likely going to get. Here, the action is beyond intimate—it's now almost uncomfortable, and it adds resonance and significance to a particular scene (*Citizen Kane* uses the extreme close-up in a very famous way in the "Rosebud" scene, and the *Blair Witch Project* movie uses it effectively during the confession scene to denote fear and confusion).

These shots also apply when dealing with high angle shots, and their cousin, the low angle shot, where we now have a low vantage point looking upward, making whatever we look at seem more majestic. Case in point:

let's go into the next page of *The Solution* narrative and reveal what stopped the kid dead in his tracks:

The flying man (the Solution of the title) hovers over the kid, ominous and threatening, breaking the fantasy the boy had with his toy and making the reality of a superperson flying over you seem... creepy, really. In order to showcase this emotion, the character has to seem bigger than life, and he has to be framed in a way that threatens the viewer. This is why the shot has to be a low one, as it dwarfs the viewer in front of the magnitude of the character. Also, the background stretches out into the sky, thus showing just how huge and scary the idea of height can be to a kid (and feeding our own underlying fear of heights or, more specifically, falling; sure, not everyone has a phobia about heights, but no one wants to fall and feel pain or worse, right?). All of these elements combine to both change the mood of the narrative as well as change the direction of it and add drama to it, and thus creating the conflict that we discussed earlier.

Finally, let's close out our narrative with this next page:

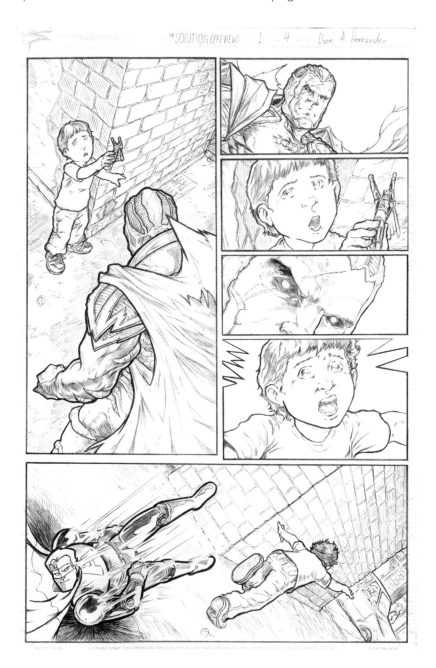

Now that we have a better understanding of visual flow and how each shot can contribute to the story, we can close our narrative effectively. Notice how some of the shots we discussed earlier are in full use here, each adding a certain meaning and context to the situation. From a high angle shot dwarfing the kid when compared to the imposing flying creature to close-ups and extreme close-ups showcasing the mood and tension of the scene and a final shot of the kid running away and dropping his superhero toy, we have a nice balance of shots that are entertaining to the eye, keep the narrative from being repetitive, and allow for the story to resolve itself.

Some comments on that final panel:

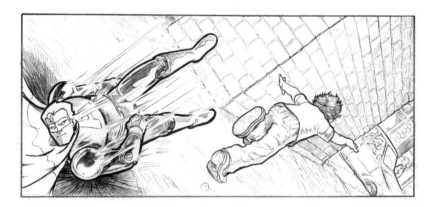

We have here a *bent horizon*, or a shot that is supposed to be viewed diagonally. This is generally called a *canted* or *Dutch* angle and is usually used to denote an imbalance or a figurative weight shift in the scene (though sometimes it's used in rather obvious ways; in the old *Batman* TV series, the criminals were usually viewed in canted angles because—get ready—they were shots of characters that were "crooked"—sigh—gotta love that show). Also, you'll notice that although the toy is obviously the main focus point of the scene, there is more of the background in use, and there is more of a sense of depth and space throughout. This setup is different from a full shot because the background is just as important as the action within it, even if viewed completely. These types of shots are called *Wide Shots*, and are generally used as establishing shots or in situations where the environment is either as important or more important to the scene as the characters within it. Also, keep in mind that shots can be combined (the last shot was both a wide shot and a canted shot) and can be used for different angles, purposes, and scenic moods (perhaps starting with wide angles and closing in

on the action, or actually starting up close and moving away, in which case we establish a personal situation and then move to the global):

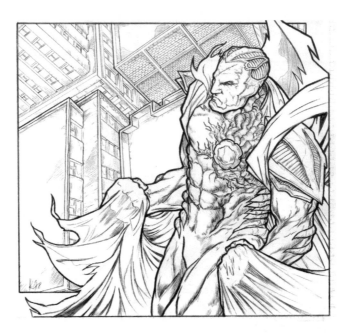

As we continue to navigate through the many ways environment and layouts can help you tell stronger stories, it's important to once again remember that all of these concepts are meant to serve as tools for storytellers to develop their tale or to enhance the overall experience of an audience member as they witness said tale. Thus, all these shots, all these spaces within dimension, all the key props, and all the visual breakdowns are there to enhance a scene's focus and overall point. You must first figure out exactly what you want to say with your illustration, your game, or your comic, and then you can better use these tools to present this point effectively.

In short, be sure of your world before you enhance it. Only then will you have an effective and memorable environment for your story.

Act 2

Danger: Trespassing!

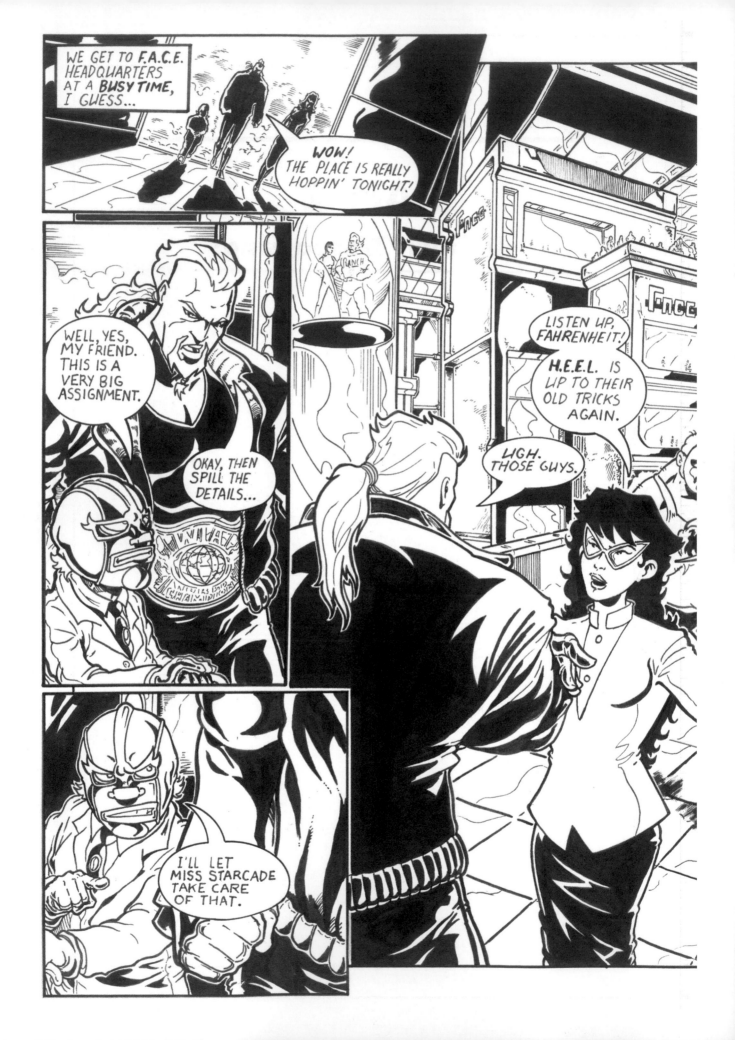

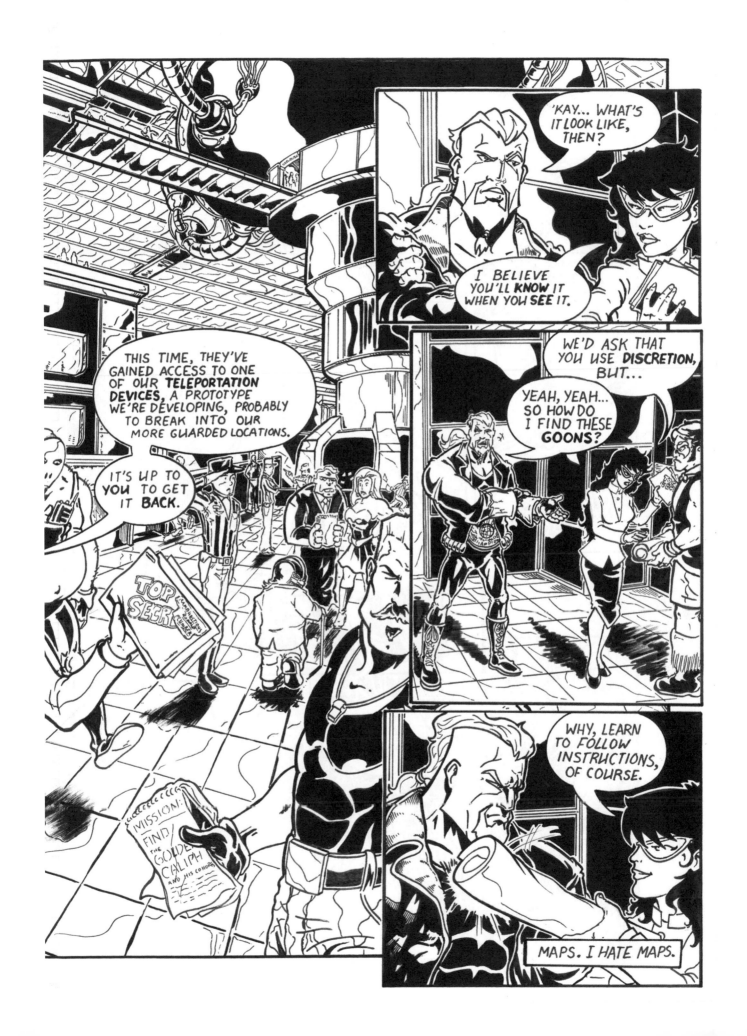

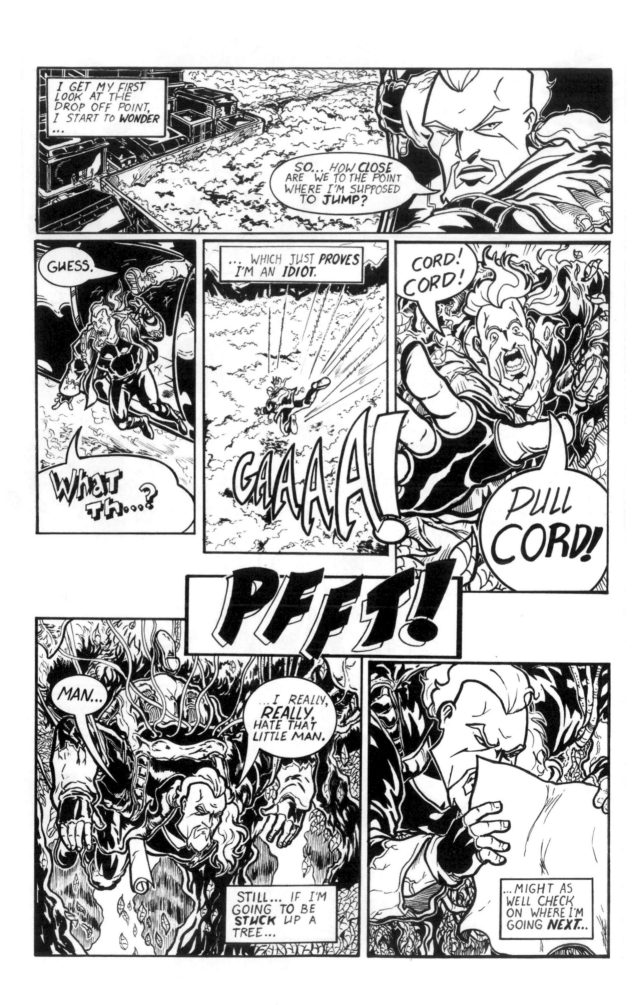

Section 3

Minding Your Surroundings

Well, well . . . things are about to get dangerous (and fun!) around here!

Now that Mr. Fahrenheit has his marching orders, here are ours: using what you've learned so far about layout design, we must go even further and expand your knowledge of backgrounds and stage play to create stronger, more engaging narratives. This will require adding just a little more to your repertoire of techniques—that is, ways in which we can add a little more of a sense of reality to our worlds. It's time to get a better idea of where we are, so we can better prepare for where we're going.

Within this section, you will get a stronger sense of texture in your environments, learn more ways we can present shots to ensure higher dramatic effect, and start to add more than just characters to your scenes. We'll also begin to prepare our visual storytelling to evoke the mood and feel we want our stories to have.

So get ready: things are about to get a lot more exciting around here . . . and I'm not just talking about the crazy super-spy wrestler! (Better add that to the list of sentences I thought I'd never get to say.)

TEXTURES IN BACKGROUNDS

Because the last two chapters went from dealing with environmental layouts to storytelling structure and the beginning of the full connection between the two, these next chapters are meant to tie both concepts even closer together. This way, you will not only develop your artistic eye but also hone your instincts for applying it in storytelling. We begin this process by adding more life and grit to your pieces through *texture* work.

Earlier, you studied the concept of line weight in design and how it can affect the illusion of distance and depth within a particular image. However, there are other elements that determine the physical context of a piece and can also help our sense of proximity. Take, for example, the following image:

All things considered, this isn't a bad image, is it? We get a sense of distance, and we see structures we understand. Yet our ability to relate with the environment is compromised simply because there is no grit to it, no sense of what we would feel if we were to touch the surface. In short, everything is too clinical. Now, let's view the same environment with some texture:

Better, right?

Suddenly, the environment has more life and feels more inhabitable (or even better, inhabited). That's because we connect what we see with a concept of what something should feel like, or how something should affect us, constantly. Think about it: you see a delicious meal in a picture, and your head starts hitting you with promises of how it will smell and taste. Yet if we were to see the same food a week later, moldy and gross, we have another reaction altogether (don't worry, folks—no photos of these examples will be presented here, but you get the idea). Thus, how we present something has a direct connection to how we relate to it and how we react to it or, more important, how we want our audience to react to it.

We arrive, then, on the concept of texture in design. *Texture* is the use of lines and shading on paper to create the illusion of a tactile experience in an illustration on a two-dimensional surface. For example:

Here are two rocks, each recognizable and accepted by the viewer. However, each one represents a different surface and a different type of rock. Let's look at the first one a bit more closely:

As you can see, this rock represents a lighter, smoother surface. How do we know this? Well, take a look at its *contour line* (or outer line, as it were): the line is continuous and round, without any sharp edges or intercut marks. You may notice that the lines are also drawn in conjecture with the actual shape of the figure (with heavier lines where the shadows should be, yet all of them are smooth). Now, let's look at the second rock:

Here we see some sharper lines, intercut and broken, with no continuous flow. Also, we see some smaller, sharper lines where the shadows should be, indicating a rough, corrosive exterior. Thus, the second rock should look like rubble, or a sharper, more dangerous rock (though, if thrown at you, I would assume both rocks would hurt).

These types of lines are not limited to rock types. Let's view them in the context of a different type of surface, such as an automobile. First, let's view the car as clearly as possible, with no texture lines, just outer lines and components:

Now, let's add some of the smoother, longer lines we saw on the pebble on the bonnet and the sides:

Because of the longer lines along the top and the sides, there are some indications of a smooth surface, as if the automobile has either been recently shined or recently purchased. It's definitely not a car that's seen a lot of driving beforehand. But now let's use the second rock as the basis for the lines on our car, especially near the shading and lower parts:

This car has seen some action! The lower, shorter lines can indicate dirt or corrosion to the side of the car, giving it a bit more age and definitely adding to its overall look. Also, there are some longer, intercut lines that remain sharp but are bent as well. These could indicate some wear and tear, or even some dents throughout.

Each one of these illustrations is representative of different types of cars and is practical in storytelling. You can also use a combination of both types, at different levels, to tell something different about the car. For example, this car:

could fit a scene like this:

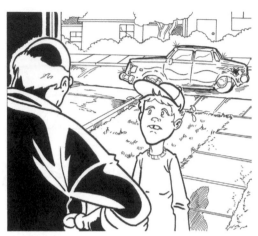

and thus fits the storytelling completely. Poor guy.

Although we will be covering props and vehicles a little bit later, it's important to remember that the way we represent objects in the environment is extremely important, as is the representation of the environment itself.

Let's look at the following scene as an example:

Here we have a warrior elf standing in a rural environment. Let's study the character within his environment and see how the texture works throughout. First of all, in the background we have a lot of intercut lines, indicating a sharper, outer design. But look at the ground:

It's a mix of both rounded out lines as well as intercut, shorter lines to better represent both the natural surface of the ground as well as the regular grit of dirt and soil. Let's shift our attention to some of the plant life in the scene:

These lines have smoother outer surfaces; they can have intercut lines within the structure, yet all of them stretch upward, as they also help to indicate organic life, which tends to grow toward the sun and water sources like rain. Also, if you look at the base, the outer lines start shifting toward the ground, blending and intercutting, giving the illusion of roots going into the surface. In both examples (as well as throughout the full image), all the lines meant to show grit or shadow are done toward the shape of the actual surface; this approach is meant to showcase the natural workings of light and shadow (as line weight also tends to do) and to show how texture responds to circumference and shape.

Look at these cylinders to illustrate this point; each is supposed to represent light and shadow, but one uses flat lines and the other uses lines bent to the surface to present this point:

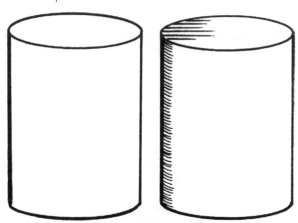

The second image definitely feels more natural, with the shadows falling into place and adding to the overall feeling of dimensions in the piece.

Some line/inking techniques for *textures* and *shading* include (but are not limited to) the following:

- *Cross hatching:* The use of intercut lines to create the illusion of light and shadow; the tighter the lines, the darker the surface.

- *Intercut lines:* Lines flowing in a particular surface, but broken at even spots to indicate a lack of focus or clarity on the texture (think the Invisible Woman, if you need a reference).

- *Solid lines:* Lines of a particular weight and substance, continuous throughout a surface, indicating a strong, rigid shape.

- *Fluid lines:* Lines in a variety of weights and shapes, but continuous throughout a surface.

- *Sharp lines:* Lines done in short spurts, covering an equal area, indicating a rough surface or a sharp, gritty feel.

- *Layered lines:* Lines drawn out, short but in the same direction, leading to equal line in a different direction, usually used to create a smooth surface with some texture, like processed wood or smooth cement.

- *Spirals and layered spirals:* Lines drawn out in a circular motion, either oval or outstretched, to indicate rings on wood or natural texture.

- *Spot blacks:* Large areas of just black color, indicating a heavy shadow or complete lack of light.

- *Feathering lines:* Line technique using curved, rapid lines drawn out to give the illusion of a feathered or cylindrical surface.

These are just some examples of the line work you can add to an illustration to add grit and texture. They are not the only ones, and they certainly work best when combined. One thing you'll find as you continue through these chapters is that most of these concepts are meant to be discovered through practice. You'll find more lines that work for you as you hone your craft, and you'll learn when to add texture and when *not* to (remember that objects closest to us have the greatest detail, and so have the most texture, while objects farther away from the viewer tend to blend together and become basic shapes). Only through practice will you get pieces that not only work but also work for you and your storytelling needs.

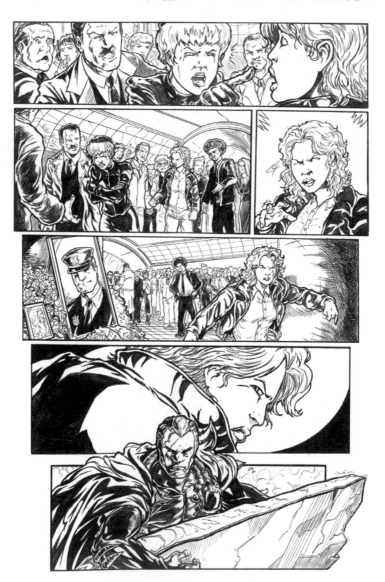

FOCUSED STORYTELLING

As we continue through this exploration of background design, it is important to understand that these are all *tools of a trade*, but the trade is *entertainment*. The funny thing about being a *media artist* (an animator, a sequential artist, or a game designer, among other types) is that we have to be showmen as well as illustrators, designers, and so on. Our main objective is to create a solid narrative that makes you feel something. We (and that includes you, too, faithful reader!) have to find a way to engage an audience in a conversation and make it as dramatic, exciting, and daring as possible. This means that no matter what lines you put on a scene, how much texture is present, or how well the layout is working on a particular shot, if you can't relate to the situation being presented, all these features are going to fall flat.

So, the first thing we need to determine when we are creating an image is figuring out the image's actual *purpose*. Once we have that, then we can bring all elements together and really get strong layouts and visuals together.

Let's take the cover of this book as an example. In case you've forgotten it, or don't feel like closing the book to have a quick view, here's the line art:

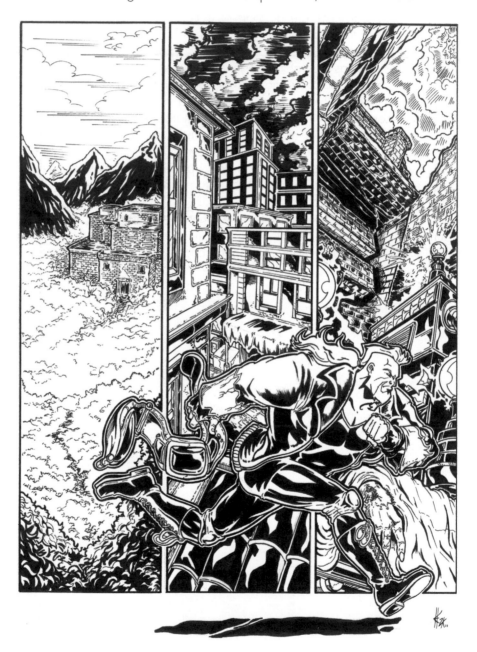

Here we have three different environments showcased with a figure in the foreground. The environments are meant to be different from one another, each evoking a particular feeling or mood, and implying the idea of a worldly, wide scope. Our character (Hi, Felix!) is in the foreground, running with

authority, very dynamic in his posture. All of these elements should create a sense of "Action!" and the feeling should be exciting in nature.

In short, our *focus* is to present something different from everything else on the racks so that a possible reader, scanning for books on background design, will look at this book and say "Ooooh! That's the one! That one looks exciting!" So, yes, the focus is to sell the book, pure and simple. And if you are reading this, chances are good that it's worked.

The focus of a piece is a bit of a *mission statement*, sometimes unwritten, that creates a central concept for a particular piece. It's the use of all the elements we've talked about (framing, blocking, layout, texture, and composition) toward a defined and clear objective. Sometimes it's as simple as "Here! Buy this!" though usually it needs to be a bit deeper than that.

Here's a recent assignment I completed as an example of focused storytelling developing the layout of a piece. I've been doing some cards for game designer (and fellow writer for Focal Press!) Bryan Tillman from Kaiser Studio Productions. These cards are for a tabletop game he is developing, so each card represents either a different power, ability, or concept that needs to be represented in a clear way, yet remain interesting.

This card, for example, is called *Barbarian King*:

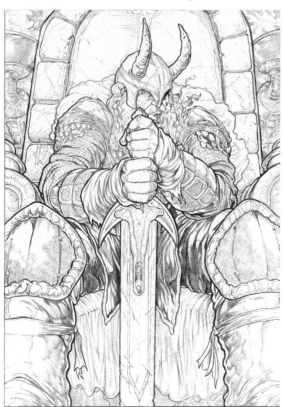

All I received as a mission statement for this piece is just the title of the card, so I had to sit down and figure out what "Barbarian King" means to me. First I did a couple of sketches:

These are *concept thumbnails*, showing what went through my mind with the piece. As you can see, some of these are meant to be action pieces, with the focus being "power," and really focusing on the "Barbarian" part of the

equation (I'm a Frank Frazetta fan, after all). However, something else that I started thinking about was the "King" part—an old king, one who has seen battle and wears a heavy crown. So I came up with the last sketch, one that presents the character as a figure with lots of power, but made him regal and ancient, like a Nordic god. So, the clear focus of the scene is "power, royalty, respect, and wisdom." This focus helped me get to the next steps: *research* and *reference*.

I can't tell you how many times I've heard new and aspiring artists say that research and reference are somehow akin to "cheating." Apparently, we are supposed to come up with everything on the page from our mind. Which must be nice, I guess.

Except that nobody is that smart or original. Sorry.

Oh, sure, with time, instinct does take over, and there's a lot of stuff we create on paper that is 100 percent built from our own imagination. It's what makes our artwork "ours." However, developing texture, authenticity, and likeness? Yeah, those can't just come from us; they have to come from looking at something and understanding what it is we are trying to represent on paper.

First, I looked up different types of armor and textures:

Then I looked at rock textures and surfaces (the idea I had for the piece is that the throne, sword, and all the outerwear on the character need to look

old and beaten, but strong; I wanted him to look like a survivor, and part of an even older tradition):

These are only samples of some of the reference obtained for this piece. You want to make sure that the feeling provided is not one that is completely alien to the viewer, which is why I use a lot of stuff that is readily available around me as reference, while I also search out more specific resources. A household chair, a piece of decoration, or different types of walls and nearby rocks can be as valuable as picture reference, because they give you (the artist) something you can feel and touch. You can't understate just how important it is to have a *tactile reference* present for an artist; if we understand how something feels to the hand, it will be easier for us to render it on paper.

From here, I create a tighter (though still somewhat loose) *thumbnail* of the actual visual, and then start the process of *rendering*. Using all the reference available, as well as keeping to the central idea of the piece, we can

enable the environment to accentuate the focus of the piece onto the central character and thus create a memorable visual:

See? The textures of the environment, the distressing on the sword and clothes all go together to create a stronger image. But the piece could not gel without a clear idea of what it is we want to accomplish with the scene.

As you go through the chapters, you'll see that this concept of focus applies to everything we do, not just single images. Pages of sequential storytelling, pieces of animation, and interactive game levels also need a certain promise of commitment from their artists. You have to be ready to go the extra mile and to do what it takes to get your point across. Only then will your designs truly pop.

Next, let's get a better look at these places we're building.

FLOOR MAPS AND SHOT LISTS

Navigating a set environment piece can be a bit confusing. When you add setting up the different shots that involve a particular frame of visual storytelling, the task becomes Herculean. Thus, our environments require a certain level of consistency to keep the narrative flowing naturally. For example, let's look at the following page:

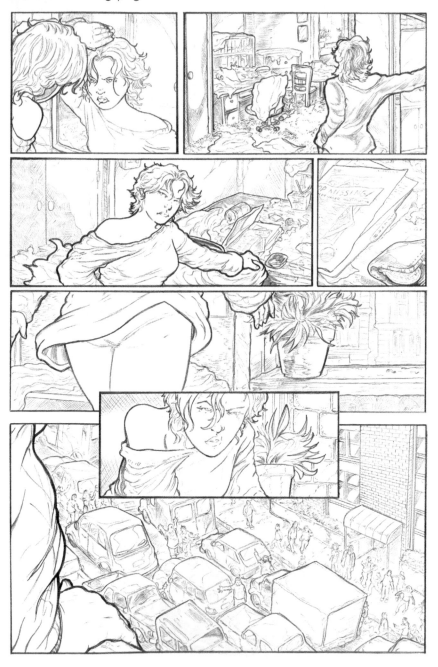

Here we have a bit of limited information concerning the interior of an apartment, personalized for the needs of a specific character. In this case, the character is having a rough time, and the apartment reflects it. However, no matter how roughed up the apartment appears, the actual area it occupies cannot change size or shape simply because we are using a different angle.

The layout of our playing field has to be established within the shots used. As we move forward in the scene, there has to be enough information within the shots so that the audience has a better idea of the apartment's size and space. Because of this, the artist needs to know exactly the space that is being dealt with before the shots are planned out. Because of this, it's probably a good idea to develop a *floor plan* (or *floor map*) of the space required so that the continuity can be kept throughout.

Floor plans should be nothing new to people; we see them pretty much everywhere. They are generally an architectural tool, serving as a map of a particular environment or allotted space, while taking into account the overall structure of a whole building as well as its individual units. A floor plan should not be a necessity for the enjoyment of a scene (there aren't a lot of visible maps of scenes in cartoons or comic books), but they can definitely be an incredible asset to artists, especially in situations where more than one artist has to work on a particular project, yet the project has to have a continuous aesthetic sense.

For example, the floor plan corresponding to the previous scene would probably look as follows:

Using this plan, we now have a better understanding of the visual at hand. All the spaces are labeled and developed to understand space in a basic sense. However, we might need a more detailed understanding of the environment because, for instance, props within it are going to be integral to

the story as it goes on. In such as case, we might want to create a more detailed map:

Much like all other concepts and features, the focus and purpose are key; if our goal is to just try to determine our working space, then the first plan works perfectly. However, if we are setting up a working space as a stage, where marks and spots need to be labeled and props need to be evident, the second example serves us better (there are also cases in which a combination of the two works perfectly, such as board games like *Clue* or *Candyland*, in which the environment needs to be viewed to be navigated, or maps in video games like the *Zelda* games or *Assassins Creed*, in which the environment is *so* big that an understanding of the lay of the land is completely necessary).

However, with either of these maps, we can now view a new scene:

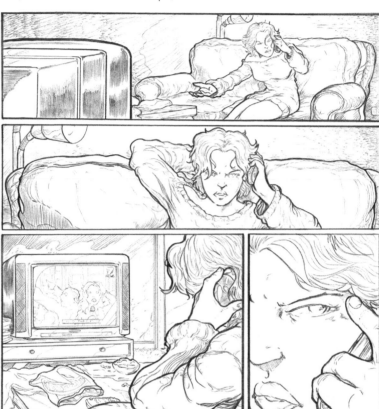

And now we'll know where the character is in correlation with the rest of the apartment, and we can use that relation in following scenes.

Floor plans can also help in the blocking requirements of a scene. Say we have the following floor plan as a basis for a set of scenes:

We are establishing a set, which will serve as the layout of the environment we want to render. Remembering that the size and shape of the environment will not change throughout, let's set up a couple of different shots in this room:

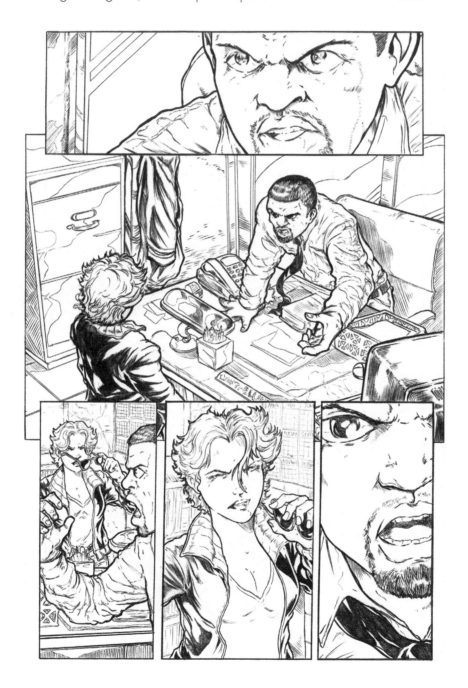

Let's look at that second, larger panel. The angle at which the scene is being shot seems to be from the bottom right of the office, at a slight high angle, framing both characters in the scene. If we were to set that up on a floor plan before we were to draw the scene, we could represent it like this:

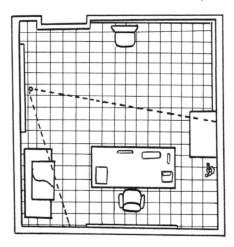

Now we not only know the type of shot that we want but we've also established what would be visible within said shot, thus helping in the upkeep of the visual continuity. Next, looking at the following shots, we could break them down as follows:

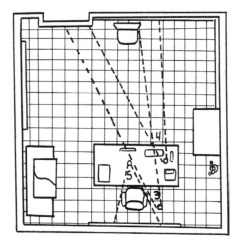

Get the picture? Our stage is now stronger and deeper due to the understanding of our layout.

Floor plans are not restricted to interiors, either. Mapping an established environment can not only make blocking a scene a simpler task but also allow

us to measure the length and trajectory of an action and help us keep the consistency going, in case the narrative requires us to return to any of our previous locales as the tale progresses. Let's see another example:

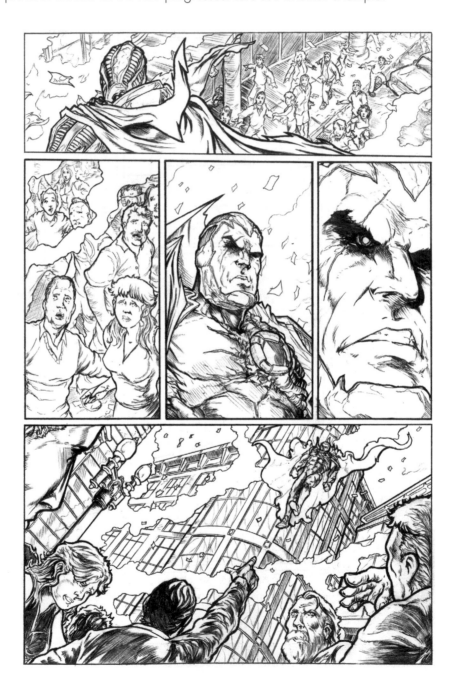

Here, we can visualize a floor plan to create the outer stage on which the action would take place so that we can maintain *consistency* for our shots (film crews go through a similar process when setting up complicated stunts involving a lot of road space):

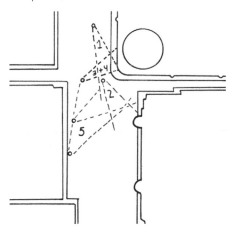

Finally, another use for maps in terms of consistency is to be able to pass along a set of rules pertaining to a particular stage/ground to more than one artist and to have the environment be consistent throughout a production. For example, using something like this:

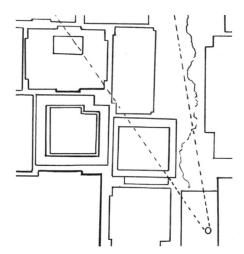

allows us to visualize an environment in a wider manner:

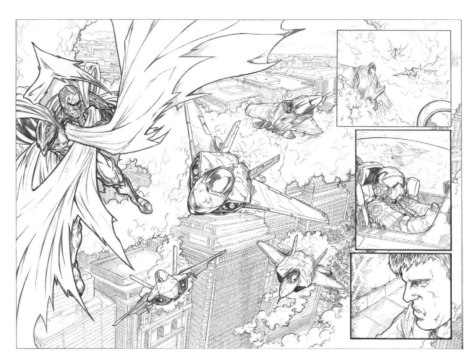

while still allowing for someone else to be able to visualize continuing scenes while keeping to the environment preset by the previous artist.

You might find yourself working for another artist who has already made a name for himself/herself with characters and worlds that are set in stone. Floor plans and floor maps, along with *style* and *model sheets*, will become essential to you and will make maintaining the style of the original piece a much easier endeavor.

And, hey, you'll be happy to develop them if it's you passing a story along to someone else! You never know.

PROPS, OBJECTS, AND VEHICLES

One of the many techniques that theater actors use to create a character on stage is to develop a *relationship* with a *prop* or object within a scene. Now, I'm not talking "to honor and obey" here—I'm talking about the way a character holds a glass, handles a watch, sits in a chair, and so on because

the way we behave within our surroundings says a lot about ourselves. For example, say we have the following *character sheet*:

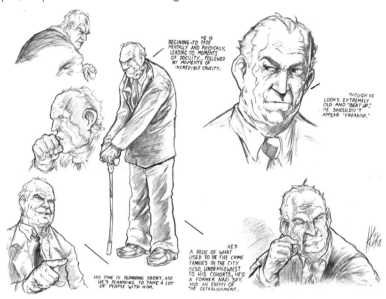

Here is an old-school Mafioso character, the type of guy you'd find in a gangster novel or a detective story. The character is supposed to be old (older than most, anyway), so his posture should be affected by age and illness. That is why his cane is so important: it serves as a tool for support and to enable movement. In opposition, we have a police character, a young detective looking to make a name for himself:

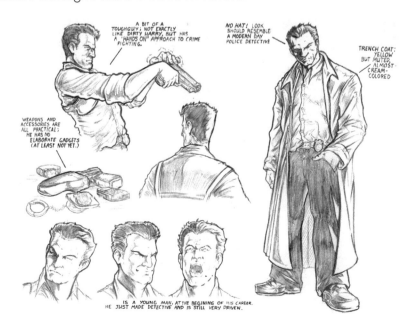

As you can see, the relationship with the prop is different here. The prop (in this case, a gun) is meant as a defensive weapon, so he will be handling it with a lot more force and determination than the mobster would use with his cane. Thus, the prop helps develop the character and cements the focus of a scene.

In terms of layout and environment design, we have to think of props in terms of how they affect the landscape of a particular visual, as well as how best to place things for the purpose of interaction. We've already gone into some of the techniques by which this is possible (placement of key props, line weight and rendering techniques, blocking) but now is the time to put them in use with more of an eye toward the props themselves. Let's look at the following scene, for instance:

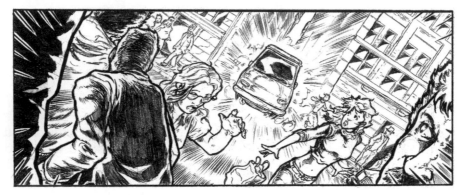

The weight of the scene combines a couple of techniques to create tension and suspense, but one of the key bits here is that all these physical assets, such as tables, bags, or the cars themselves, feel like what they are supposed to be: we recognize the prop, so we recognize the danger provided.

But how do we make these props (the car, for example) feel so natural and interactive? The same way we have been working with our backgrounds and our figure, actually: we start with *grids* and *shapes*.

Everything in illustration can be broken down into basic shapes, right? It's the same way we can take a character and break him/her down:

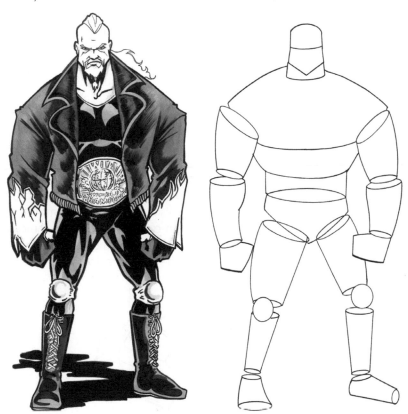

which in turn is the same way we break down a piece of equipment, an object, or a tool:

Because of this, we can also adapt the concept of foreshortening the same way we do with figure:

This technique can be even better represented by taking the concept of our grid systems (in this case, a two-point perspective grid) to represent the actual relation of the gun to the horizon, in correlation with its placement in the scene:

In a couple of ways, this setup is a bit easier to work with than the human figures we are used to; we are breaking an object down that is essentially built on the concept of a couple of rectangles for a three-dimensional illusion. Now, the details on the gun and the texture on it are going to depend on you: you must remember all the other elements discussed, but most important, you are going to remember to do some research and reference work here so that the gun remains consistent with what we know guns tend to look like (even if the gun is an invention of the story). Again, here, all previous rules apply.

Now, onto our car:

As you just saw with the gun example, we can break all this down into basic shapes to better get a sense of the mass necessary to create our vehicle (it's a bit like making a sculpture, in a way). Now, with the car, what we're really dealing with is two clear blocks, one for the top and one for the bottom:

The same way we *block off* the area of the car's outer structure, we need to block off (or rather "cylinder" off) the actual tires in the piece:

As you may have noticed, not only do we take into account where our side of the wheel is but also must figure out how all the wheels fit into the full structure of the vehicle. We are, after all, trying to create something that has dimension and weight to it (as we move forward, you will see that we are going to deal with all these elements individually, because they are all fully functional tools within a larger, more complex tool).

Next, let's start *sculpting* our car out. I'm pretending we've researched the look of the car and decided how we are going to represent it in our story. (Research tip: it wouldn't be a bad idea to get yourself some model cars or toys as part of your research arsenal; don't make it your primordial research tool, mind you, as you want to actually see what it is you are emulating, so photos and, preferably, the actual car would be the most effective. Still, it's good to have something physical to look at.) Using these references, we start breaking the car down, figuring out where we want our features to go:

We cut out all those parts that we don't need and focus on the texturing and light source we want and voilà! (or "tadaaah!" or whatever): we have ourselves the car!

The same process can be done for all sorts of vehicles, such as jet planes:

Here's a perfectly functional, practical (nah, it's just cool) fighter jet plane. Yet this most complicated of transports breaks down into simple cylinders and triangles, all meant to mimic the aerodynamic elements that make birds glide (or fish swim, for that matter!):

I'm not expecting you all to turn into engineers, but it's helpful and important to not only understand how an object or vehicle looks aesthetically but also understand how an object functions, as well as its purpose. Furthermore, as

mentioned before, it's important to remember that these vehicles are made up of even smaller objects, each one having its own reason for being (like, say, the wheels of a car):

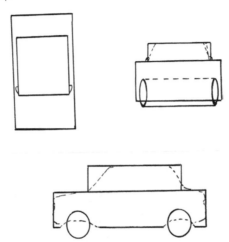

It's not that different from a living organism in that respect, actually. Think about it: we are also composed of fingers, toes, legs, arms, torsos, and so on—not to mention that each part has its own function and allows for even bigger movement to happen throughout.

Having this knowledge can also be useful for shots like this:

Knowing how the car would function (or crash, really) in a situation like this adds to the storytelling and gives a sense of implied reality to the proceedings, making the action seem more dramatic and exciting.

Finally, we must remember that all the lessons so far apply not just to buildings or characters but also to props and vehicles. Placing said props in actual environments requires an understanding of layout, space, and dimensions. Let's look at the car we previously used as an example in a basic environmental grid:

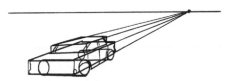

Using the car as our key prop, let's add a character and a light background to enhance the scene:

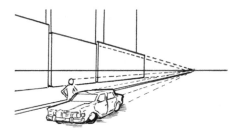

See? The car sets up a measure for creating the environment while it gives the audience a place to focus and understand the layout.

We are now getting ready to *focus* our environments toward *specified storytelling*, and here is where all these concepts are truly going to start blending together. From now on, we will be accentuating all the previous knowledge you've acquired in these chapters with a more measured, direct mission within the narrative.

Up to this point, we've been drawing backgrounds. Now, it's time to meet them.

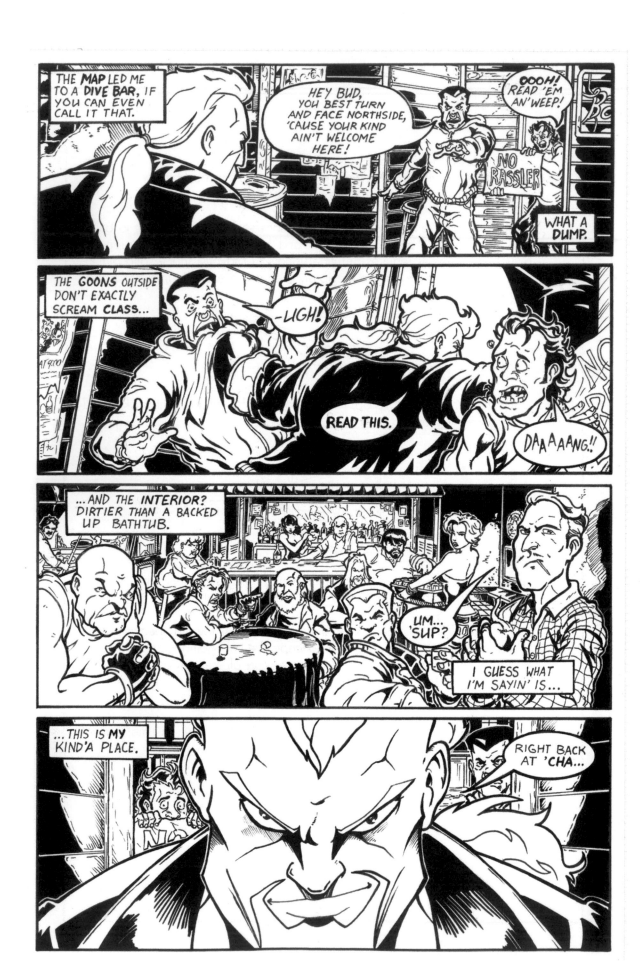

Section 4
Familiar Grounds

Whoa . . . this will not end well.

Bar fights, ne'er-do-wells, and low-grade cesspools are things that most of us generally steer away from, yet Felix Fahrenheit welcomes these sights with not only comfort but also some sick glee. Actually, he seems at home, which—if you've been paying attention to his actions and personality so far—shouldn't be that surprising.

These places fits his character, and vice versa. But what if he entered a brightly colored pastry shop, completely filled with kids screaming for doughnuts and candy? Or a high-class mall filled with stores employing snooty attendants selling overpriced garments and accessories? How would Felix react to that? We won't get a direct resolution for these questions in the following pages, but we will theoretically begin the process of figuring out answers as we view not only the relationship between characters and their environments but also just how much personality these environments actually have.

We'll explore what *color*, *lighting*, *composition*, and *iconography* can tell us about our illustrated worlds. We'll also find new ways to make a scene (and scenery) be scarier, happier, and sadder while adding *mood* as well as emotion to your narratives, using color, angles, and placement of focus. Before we're done here, you won't just enjoy looking at your backgrounds—you'll actually care what happens to them as well as within them.

Felix Fahrenheit's adventure continues . . . as does ours! Proceed!

CHARACTERS AND THEIR ENVIRONMENTS

Let's focus on you for a minute, shall we?

You are an individual, with specific tastes, morals, and ideology. Though one of many with similar problems, concerns, or personal triumphs to make you relatable to others, you are unique in that the way you deal with all those issues is specific to your needs. Because of this, you change depending on your environment as well as the situation you find yourself in.

Think about it: the way you would behave in school or at work changes depending on the situation. If you are meeting with your boss or your principal, you'd act a bit more seriously, and you'd definitely respond (ideally) with a bit more respect (or at least you'd be a bit more guarded about your dissidence). Whereas at break time or recess, when you are hanging out with your friends, you are a bit less guarded and allowed to be a bit more like "you." Now say we remove you from work and place you in a bar or a club: your attitude changes completely, even if you are still with someone of authority. This is because the environment should invite relaxation and comfort; you are just hanging out, being casual (this is why so many business meetings tend to happen during lunches; it gives people the chance to speak a bit less formally and become less guarded . . . which can also work against them, if they're not careful).

My point is that we *adapt* to our environments and that those environments become part of our personality.

Let's take a character we might find in a comic or animated show:

Here we have a "Flash Gordon" type: a stoic, muscular hero, very much the kind of character you would find in a place like this:

Looking at this environment, we can make some assumptions not only about the character but also about the type of adventures we'll be following as we continue the character's narrative. However, take the same character and place him in the following environment:

Our hero would certainly stand out in this place—and he'd definitely have a problem fitting in with the background. That's because the character is readily identifiable as an "action" character, so that placing him in an environment like this might be in contradiction to his nature. Yet there are stories you can tell here, and it still offers narrative opportunities for our character (we could have him establish a secret identity, or he could try to make misguided attempts to have a regular job while still being "super"—the sky's the limit, really). We just have to let the character adapt (or try to adapt) to the environment and watch what happens next.

Take the following scene:

This is yet another card for the Dark Legacy card game (this one called Berserker). With that moniker, we know the character has certain attributes that should be represented within the environment: he should exude power, he should seem unhinged, and he should look dangerous.

Well, let's look at his surroundings: the place looks lifeless, with smoke and carnage left in the wake of our Berserker. There are bits and pieces of potential victims surrounding our main figure, and the ground itself has no sign of vegetation or growing life. Also, look at where our vantage point is in the scene: it is low, with our character seeming larger than life (it's an eye-level shot, but the horizon is low on the shot, making the character loom over us). Because of this, our figure looks mindless in his rage—almost feral—and it brings out the character attributes we want to focus on.

In contrast, we have the following scene:

Here, we have the opposite effect: we have a pretty dingy hotel room, as desolate as the battleground from the card, but here the scene is meant to showcase the character (a young woman) in the midst of a predicament, possibly with the law (the x spots are meant for inking purposes, by the way; they indicate where spot blacks should be). The environment pushes that forward and makes her worried disposition clearer to the audience. The fact that it's a high angle shot makes this even more evident, making her seem small in her situation and indicating her state of mind. Thus, the character is built up by her surroundings.

Going back to scenes in which the background adds to the characters by opposing what the character is supposed to be, here are some comic strips to make this point a little clearer:

Poor Vic Vertigo, doomed to an interesting life due to an interesting name. But the character to watch here is Doctor Destructo—which is, amazingly, not a name that's already been taken; I mean, isn't it a no-brainer? Doctor Destructo is the type of character who would thrive in a regal, fascist environment or as a despot attacking the Flash Gordon–type character presented earlier. Yet here, because he's ranting and raving outside of a diner, he loses some of his dread-inspiring powers and becomes almost a figure of ridicule, as in the next part of our tale:

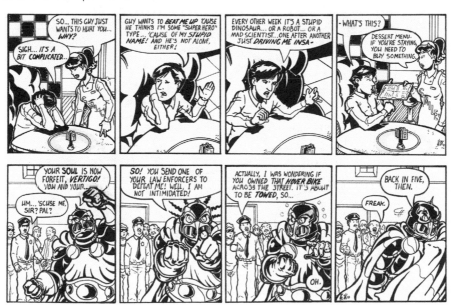

Another point is just how nondescript the environment is: it's a diner, a regular place in a regular world, which fits Vic Vertigo just fine. The whole point of the character is that he brings the baggage of excitement to a normal world, but it's the normal world which he wants to fit into, not the fantastic one. Thus, the real world has to be as "normal" and "boring" as possible so that the elements of action and adventure pop out more.

Now that you have seen how fictional characters can be as clearly identified by the places they populate as they are by their actions and their motives, you understand how the places they populate tend to inform said motives as well. Knowing this, let's see how an environment can represent a character and his/her motivations even before the character shows up on the scene. Take the following sequence, for example:

We see a visit to the circus, presented in a way that is fun, enjoyable, and energetic. We get a nice establishing shot of the tent, we see the kids running into the circus (acting like kids tend to act), we get the sense of anticipation and excitement required for a show to start, and we finally see the ringmaster ready to present the act we've all been clamoring for. All of this leads us to:

Our strongman character! You may think that the previous page reflects more about the circus than it does to this page's main star, but you would be thinking only in terms of single images and not in terms of full narrative (oh, you!). The first page is there to create *anticipation* and to set the audience up for an event in the making, thus implying that our character, the circus strongman, will be bigger and brighter than life! Think of any show or concert you may have gone to—rarely do you see a music act go up on stage on time, but the sense of *expectation* and *excitement*, as well as the shared experience of

the audience within the arena or park, adds to the tension—and an act that knows a thing or two about showmanship will use this effect to its benefit. By making the audience wait to see the character, we make him bigger, stronger, and more of a sight (of course, you must then deliver on the promise). Movies do this (think of horror or action films in which we don't see the character but we get a sense of him/her by the places we visit or the tension built before the reveal) as well as games (think of the bigger bosses at the end of levels or the full game itself; the environment tends to announce their presence without actually having the character in view). In fact, just about every form of visual storytelling uses its environments to announce their main characters, and they eventually showcase their strengths and weaknesses in a meaningful way.

With the concept of environments enhancing characters introduced, we can move on to ways in which both character and environment become codependent and how the backgrounds themselves are as much a character in the action as the main players. First, though, you must understand how to make these backgrounds stand out in the viewer's mind and connect with the viewer in a meaningful way, which leads us to *iconography*.

But, before we go:

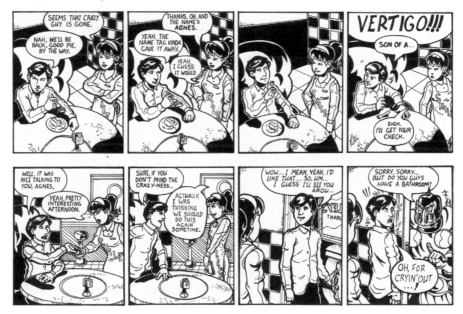

Sheesh. Isn't that always the way?

DESIGNING ICONOGRAPHY

What makes an image *memorable*?

Some would say it's all about the rendering. Others would point to the style employed. Attention to detail, visual narrative, authenticity—these features are all reasons to grab onto an image. These answers are all correct, actually, but it's the synergy that happens when all these elements work in unison that truly makes an image memorable and, above all else, iconic.

We hear the term "icon" often tied to a symbol or character that has so permeated the general consciousness that it is assumed everyone can relate to it or understand it on the spot. Movie stars, cartoon characters, logos on cans of soda, or even a certain lettering type on different signs could be pointed out as icons capable of immediate mass appeal. Yet just what is an icon, anyway? Also, how do we go about creating an iconic image, one that resonates with an audience and becomes something they readily recognize?

Let's take the following image as an example and go from there:

Santa! Toys! Yaaaaaaaay!

Ahem. Anyway, yes, this is Santa Claus, or at the very least a drawing of him. Here is a symbol that almost everyone recognizes and can identify. That's because even though the image is new, it still has all the elements we've come to accept of Santa Claus (the beard, the suit, and the bag). Let's say we want to repurpose this symbol for a more modern feel (say, for example, a kids animated action show):

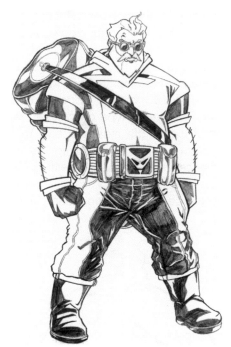

Now we're talking!

Here we have a character based on Santa, but with a different purpose. Yet he is still identifiable as Santa because he retains a lot of the classic elements

that make him recognizable—they've just been *altered* a bit. Thus the character retains the elements of the icon image, but now they are prepared for a new audience.

Iconography is not just about character; no, the whole concept has to be representative of the imagery desired. Think of Batman: he's a character who not only looks a particular way but actually affects the world around him and makes it fit his personality. He's got a bat-mobile, a bat-arang, and other bat-gadgets that help to create a full image . . . not to mention that Gotham City fits his personality completely. It's dark, with dangerous alleys; the buildings look like nightmares; the sky is either pitch black or red. The whole package creates a memorable concept and helps it remain vibrant in people's minds for years. Yet if you look at the concept itself, it's quite simple: lots of bat stuff, dark city, and colorful criminals to contrast the darkness of the main character.

So, we can say that rule number one of iconography is the following:

1. **Keep the design simple (or simple enough to be memorable).**

Tied to this concept, we can go ahead and set up our next rule:

2. **Remember your audience.**

Our cartoon about "Action Santa" is probably going to be aimed at a younger crowd, ages seven through twelve, with enough appeal that an older audience might find it enjoyable, too. In cases like this, I make the concept easy enough that a kid could both understand and (most important) draw. Kids *love* to draw the stuff they enjoy, and if you can get a kid excited about drawing your character, you know that you have a winner.

For our next rule:

3. **Stay true to the core of the concept.**

Here's where things get interesting. Now that you have the idea for your character, you have to start thinking about the *concept rules* that apply to your character. These can be best illustrated in a *style sheet* for your character, which is a type of *animation model sheet* that helps illustrators understand how a character behaves and moves; it also provides insight about some

features that might be important to understanding the character. Here's the one for Mr. Kringle:

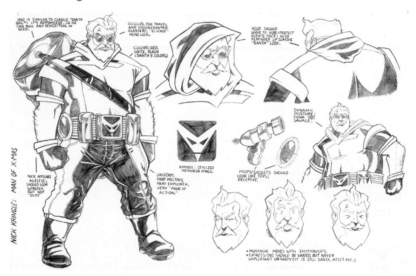

As you can see, we are now offered a better sense of how the original Santa concept ties to our concept (the hood serves as his hat, his military style bag is similar to his bag of toys, his symbol connects to the reindeer, etc.). Also, notice his accessories: they are all tied to his personality and the type of character that he embodies (toys!). This is important, not just with superhero-type characters but with any concept in animation and gaming, because you want to create an *identifiable look* to the whole of the piece, not just one character.

Establishing that his accessories will reflect part of his personality, we can assume that his vehicle will reflect this as well:

Pretty cool, right? He still retains the sleigh concept, but it's updated and adapted to the current *focus* for the character. The original Santa wouldn't travel in this vehicle, but our new version definitely would. In reality, the same could be applied to most people, really. We all have that one friend that has a particular car or bike that screams that friend's name—it's so engrained in his/her identity that you wouldn't imagine that vehicle being driven by someone else. If we were to take that friend and turn him/her into a cartoon character, that car or bike would be part of his/her *iconography*.

In that same vein, let's explore Kringle's world, starting with his headquarters:

If the character's vehicle speaks so much about their personality, his/her room has to be even more connected. Because we are trying to tie a full image to this character, his headquarters must have enough qualities to bring us back to the "Santa" idea, while at the same time fitting the new focus connected to the concept. Let's take a look at his stomping grounds:

The idea here is that Santa's workshop has been expanded to a whole town of elves, each with his/her own life and job, but it's a town in which the main economic source is Kringle's toy shop (kind of like the power plant in the Simpsons, but with no Mr. Skinner). What you'll immediately notice is that the town itself, though unique, is not as dynamic as the lead character. Here, we are trying to have the town reflect some of what's at stake for him and what he fights for: prosperity, peace, and happiness. In the Batman example, Gotham needs to look like a corrupt nightmare because the focus there is "one man against the world." In the case of Superman, Metropolis is referred to as "the city of tomorrow" and its technological advances are supposed to reflect Superman's influence, and so on. We could sit here and do this type of city-to-character comparison with many more icons, but you get the idea. It is best explained with the following rule:

4. All elements of the character's world should reflect and showcase the character, even in contradiction to it.

That last part might be a bit confusing. "What do you mean in contradiction, Mr. H.?"

First of all, I didn't know we were so comfortable with one another. Second, let's look at the following environment:

This environment does *not* reflect the character directly (his ideals, his hopes, and his duty), but it could reflect what Kringle fights against (oppression, corruption, loss of hope). Thus, it represents a challenge to our character: one that

he must face and overcome. By demonstrating the type of environment which our main character would rally against, we say much about the character's ideology, and we get to say it in a way that connects with a whole audience without having to say a single word, which brings us to our final rule:

5. Don't tell me about the character/concept: show me!

We are dealing with a *visual language* when we are talking about sequential storytelling, so there has to be information available to me in what I'm watching just as much as in what I'm hearing, or else you'll have to explain the concept over and over and over and . . . you get the picture. You have to stimulate the eye not just with cool visuals, but also with enough informative elements so that I have an understanding of the intended mood or feeling, even if it's supposed to be mysterious or evasive.

There are probably more in-depth rules to *iconography* that I'm omitting (and, if you're interested, there are many graphic design tomes from which you can get more information). However, I find that these are the ones I stick to. As I've said previously, there is no rule that can't be broken, but in order to effectively break one, you must understand its importance and your reasoning behind this decision. These rules are here to help you to come up with effective *concepts* and to see them through not just in character but also in each connecting element to character. As you'll see in the next chapter, you might include those elements under the terms "character."

BACKGROUNDS AS CHARACTERS

As we've already demonstrated, it's hard not to tie a character to his/her environment. Be it Batman and Gotham City, Archie and Riverdale, or Homer and Springfield, every character that's had a lasting place in pop culture has done this by adapting, exploiting, and embracing the environments that he/she inhabits. A change in the environment can affect the character drastically, perhaps shifting his/her focus and altering the entirety of a story. Just why is it that the environment has that much power over a character?

My friend, it's because the *environment is a character*—one almost as important as the main players in our story. Let's look at the following example to

start our character study of animation (this example should be familiar to you, actually):

This is the first environment you encountered when opening this book (unless you are like me and you flipped to a random page just to see what the layout is like—no worries, this is a judgment-free zone). We can already say a couple of things about this environment: it's an establishing shot, it's a high angle shot, it has texture, line weight, and more, but these are all technical concepts. What can we say about the meaning of this background?

Let's study it a bit more closely:

1. It's out in the middle of nowhere, so it's a hidden, secret environment. We can say that one of its main goals is to conceal, and it should be hard to find.
2. It looks fortified and strong—definitely a place that protects something (in this case, the bad guys). So, in a sense, the place is safe. However, see #3.
3. It looks ominous; it's supposed to demonstrate a sense of dread and intimidation, making the viewer careful of approaching it, in case it might be harmful.
4. It looks difficult to navigate, with multiple floors (I don't mean that the design is difficult, mind you; I'm simply stating that it looks like an environment that shouldn't be easy to navigate through). The idea is that it poses a challenge for our hero, and one he shouldn't overcome readily.

There are many other points that we could get into here, but I think this is enough to start with. What we have above is essentially a *character description*, detailing the main attributes, concerns, and threats that define a character's actions. From this list, we can formulate an adversary for our bud, Felix Fahrenheit; however, in this case, the adversary is not a person but rather a place. If you were to apply the previous description to a living, breathing character, you would essentially be describing a bully, a rough-and-tumble character who poses a threat to our main character but will eventually be beaten or overtaken by our hero.

Let's look at a different type of environment:

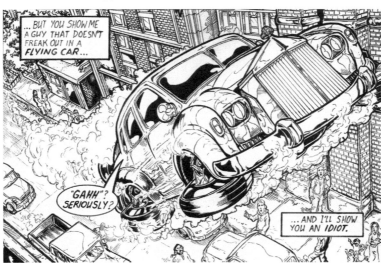

Ah, remember when this happened? Here the environment has to be in contrast with the action because the focus of the scene should be the flying car. So, then, what can we say about what we see in the background?

1. It's urban: very citylike, very open, and very populated.
2. It's relatable: nothing spectacular or amazing going on—which makes the flying car pop out so much.
3. It's . . . well, it's boring, really (not the shot, mind you, but the environment itself). It's not tranquil enough to be serene, and it's not busy enough to be one of those "the city is crazy" shots. It's just a regular city street.

The environment is the perfect setting for the flying car, because it is very much the opposite of the action within it. If you think about it, this is exactly why your favorite stories take place in the environments they take place in! Horror movies take place in secluded environments so that your characters can't find help readily available. Action movies take place either in exotic locations to match the intensity of the action or in populated environments to add to the threat level by placing so many in danger and also to contrast the mundane (our regular city world) with the fantastic (the flying car). Go down a list of stories that you like, and you'll find a fitting environment for each one.

The trick here is to build the environment as a character, and to do so, you have to get into what characters usually deal with: purpose, motivation, and conflict.

Let's look at the following scene to better illustrate these points:

If we watch the performance of both characters in this scene, we know that this is a tense, perhaps uncomfortable scene. Both the man and the woman seem to be in need of privacy to avoid tension and some embarrassment that

a public location might bring. Let's study the two environments working in this scene. First, the car interior:

Second, we have the woods themselves:

The purpose of the interior of the vehicle is proximity for the characters, as well as adding a sense of a "trap." It presents a situation they can't escape, and even though they sit right next to each other, they still feel confined within the vehicle. This adds to the perceived conflict (a breakup) and helps us focus on character.

Next, let's talk about the woods. Adding to that trapped feeling, we have an open, wooded area that is still concealed by trees and branches, affording our two characters the privacy they need, while at the same time opening up the world itself, letting the viewer know that there is other stuff happening while these two implode. Thus, the environment helps the characters keep to the scene and adds to the action itself. Plus, the environment becomes much more than just the woods or the car—it is now the place where an event that will define a character's world view is taking place. Hey, we've all been there: places that seem meaningless to some gather a lot more emotional pull if something personal happens there. The *environment* therefore becomes a *witness to the action*.

In contrast, here's a more aggressive, action-centric example:

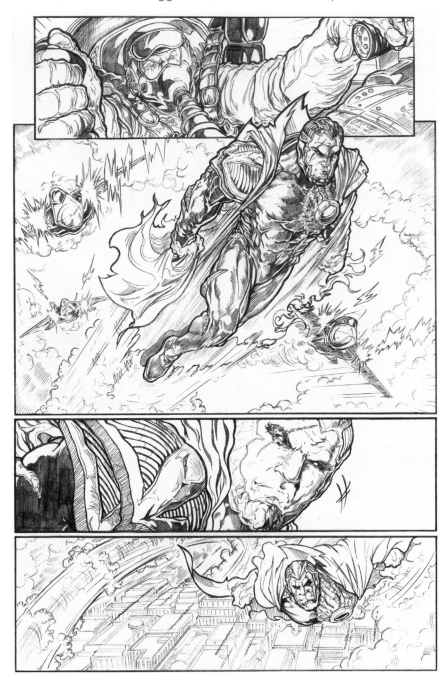

Here we have wide open spaces, lots of air, and it's above ground, where the action can take place freely. You might think that because there is so much open space, the environment is not saying much to the viewer. You're wrong, but that's okay!

The very openness of the environment offers the players multiple opportunities for enhancing the action. They basically have the entirety of the sky, while the clouds above help to either frame the action or add to it in the form of turbulence or a sign of speed. Also, let's look at the last panel of the page as the flying man takes a turn in the sky:

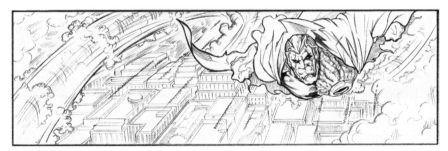

Here we have a scaling up of the action. Whereas the previous page concentrated on the personal and the intimate, we now have a page that deals with a bigger, bolder playing field. By reminding us that we are miles above ground, the action dwarfs us and makes the scene feel epic. Thus the conflict seems to have greater resonance, and our players become more dynamic because of it (what's at stake is now the entirety of the sky). We still have tension, perhaps at a level equal to that of the breakup scene, but of a different value—all because of how we showcase the environment.

To create a character, even if the character is an environment, we have to look at the *social, economic,* and *cultural needs* the character (or city) might have and how those same needs dictate behavior. Think about it: a corrupt environment in social and economic crisis tends to be the perfect backdrop for stories filled with morally ambiguous characters and dangerous types (like the bar our pal Felix has just entered); environments filled with opulence or good cheer have perhaps kinder, gentler stories and can serve to create an image of a golden era (with its people behaving in a more positive manner). These are of course extreme examples, and stories usually occur in some form of shade of gray, but you can definitely see how the environment adds to the motivations and concerns of the characters within it.

Finally, much like a character has to face both an internal or external conflict within a narrative, so do cities, jungles, and forests. One way we tend to

see how these concerns might take form for a particular character is with an *ELBOW analysis*, and this same system can work for environments as well. *ELBOW* stands for *Emotional Fear, Limitation, Block, or Wound*, and most characters tend to have at least one of these. This analysis can be helpful in discerning how best to use the environment to serve your story. Let's look at the fortress again:

The obvious fear that this environment represents is penetration of its wall: they are afraid of getting attacked and broken into. This is why their defenses are so strong, and why they are taking so many precautions (psychologists wouldn't argue too much if I were to point out that fear tends to be the number-one motivator for both defensive and offensive actions). This not only makes for a better challenge for our hero, but also makes whatever is inside said stronghold seemed more valuable. And so, if you find the biggest concern the environment has, you'll find how best to showcase it and use it more effectively to create an emotional reaction from the reader.

All elements of an environment can add to that feeling of character, not just the built-in, inorganic ones. How trees are drawn, how the ground relates to the environment, and the look of the terrain adds to a sense of danger in the previous image and contributes to the overall mood of the piece. Without these elements, we get a boring piece, one devoid of personality and focus. You don't want that.

In reality, everything presented in this book has expanded on these points. We will continue to do so in the following chapters, adding mood to the overall action, as well as a more colorful perspective (so to speak).

COLOR IN DESIGN

Most of the examples presented in this book have taken account of the fact that more likely than not, the medium available to you for your illustrations is first and foremost a black and white medium. Materials—pencils, inks, even markers—are meant to create strong line designs on paper, and the concept of texture is there to replace any elements of color that you might be missing.

However, it's important to understand how color works as well as line work, as it can be a valuable asset to any artist, and it can add to the mood as well as the suspension of disbelief one wants to achieve when creating strong designs.

To illustrate this point, let's review our cover design for this book, this time concentrating just on the line art:

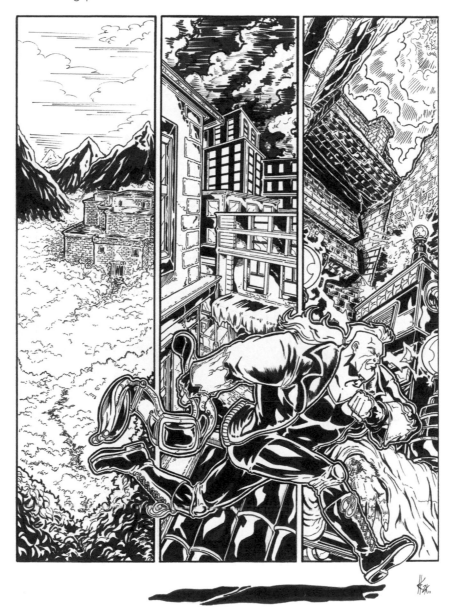

Nothing's changed, really (it's not like I went back in and did more drawing on it; trust me, it took long enough). Each environment has its own flavor and focus, while at the same time coming together with the character at the bottom of the scene to make it one complete image, not three separate images. In short, the image stands on its own, but could use something more.

Maybe (and I'm just talking here) something like this:

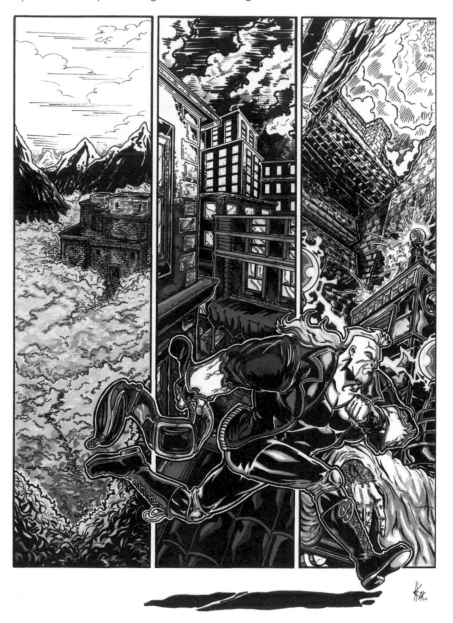

Here we have the full image, this time in color, and already we can see a difference (well, I can, anyway). Although we already had a sense of three different environments being showcased in one piece, now we really get a difference, with each place having its own color scheme and tone. Each now represents not just a different place, but also a different mood (a subject covered in the next chapter). Also, our main character pops out a lot more, yet feels more connected with the whole of the scene. Thus color becomes a part of the full design, not just another element.

Let's look at each individual environment in the piece a bit more closely. First, the rustic background with the castle:

The gold and cream colors (as well as the reds and the darker colors within) of the castle make it pop out from the background itself, which is a combination of greens and blues due to the heat that is being generated by the yellowish color, as well as the strong attention generated by the reds. Finally, the hints of orange and yellow on top of the leaves in the foreground add an element of sunlight to everything, making the image seem bright and hot in nature (a very Indiana Jones–like environment).

Next, we have the city slum view, dark and mysterious:

Here, the emotion that is being focused on is "dread": this is a dangerous place! The hues of reds in different shades as well as yellows and oranges add some heat to the scene, but the combination of red and black (both *power colors* because of their striking nature) makes the scene feel overbearing and nefarious. It all should have a feeling of *film noir* (even if, at its core, film noir is more of a black-and-white medium) with long, imposing shadows and creepy, shaded corners—definitely a different feel than the previous piece.

Finally, let's look at the last environment:

This place should also scream danger, but it's a different type of danger altogether: the concept is to be mysterious and spooky, kind of like an old horror film. The use of both blue and gray tones on a black and white background add to the dread but also give a sense of lifelessness to the piece, as all these colors are cold and somewhat muted (compared to the other two scenes). As for the warmer yellow colors on the lightning and their reflection on the surface of the environment: these provide the only sign of life and warmth to the piece (and lead your eye towards the Felix Fahrenheit character, thus becoming a layout element as well).

Using color with the right idea behind it can provide a lot of the strength and feel of an environment, adding to the ambiance desired in any particular piece. The important thing to remember here is that color, just like everything else we've covered in this book, is derivative of both story and focus. What are you trying to say with your piece and how does the color help you express that concept on paper?

Color, just like crosshatching and texture lines, casts an illusion of light and shadow on paper and represents a notion of texture and structure. It's a tool that should be treated as something that adds to the effect desired for a piece but still relates to the core concept of the piece presented. It can also add to the emotional pull of a particular illustration and can attract the attention of a viewer more continuously. For example, we have already read some information about different color types:

- *Red:* Passion, anger, rage—basically, any emotion taken to the highest extreme. It can also indicate danger, action, and power.
- *Blue:* Calm, passive, serene—the opposite of red in the emotional scale. Also, intense cold or melancholia.
- *Green:* It can mean life or greenery (plant life), but it can also indicate sickness, greed, or contamination.
- *Yellow:* On the emotional scale, it's connected to cowardice and fear, but it can create a strong sense of heat, and in a confined environment, claustrophobia (more on that later).
- *Brown:* Dirt, earth, ground; also corruption, tainted values, and deceit.
- *Purple:* Intelligence, opulence, and royalty. Characters or places with a lot of purple tend to symbolize genius at work (mad scientists, royal grounds, higher members of a fantasy-based military).
- *Orange:* Similar to yellow, it can reflect heat and strain, but it can also go into a tanned, almost baked feeling for the environment, as if the place has been exposed for a long period of time to the sun's rays.
- *Black:* Black usually is connected with some darker emotional context (death, sadness, emptiness—anything you'll find in a metal album). Yet the reason so many bands (not just metal, but all types) use black as a base color is because of its true meaning: power. Black stands out, it intimidates, and it blends in when it needs to. In that sense, it is a very positive color, indeed.

- *White:* Can mean light or purity or serene calm, but it can also mean emptiness and cold (snow). Much like black, white can have multiple uses and meanings, but it boils back down to one ideal: clean. It's not corrupted or tainted, which—depending on how you use it—can be a positive trait or a negative trait.

All these concepts feed into the main mission of any narrative, which is to both *inform* (because narrative, be it visual or otherwise, is about communication, after all) and to *entertain*. Color should make the job of the line artist easier, as it expands on the points being made in the line art.

By now you probably know better than to ask "what does this have to do with backgrounds?" (at least I hope you do). We've already discussed backgrounds not only as stages for the action but as sources of information about the characters in our story, as well as key players within the narrative. Therefore, the use of color on a set of pages can say a lot about the type of place we're dealing with and the emotion we're supposed to experience as we travel through it.

Up next, we have a couple of pages from a proposed concept called "Exit." First, let's look at the line art for the first couple of pages from the concept:

Here we have two different time periods showcased in one scene, each represented with different drawing styles: the past, which is drawn in a cleaner, cartoony style; and the present, which is drawn in a harsher, grittier style. Each is representative of the emotion desired throughout (nostalgia versus dark reality) and could function without color. Thus, the objectives of color here are to enhance the emotional pull, to create a clear distinction between both time periods, and to keep the action flowing clearly.

Let's look at the same two pages again, but this time in color (which were done by Bryan Tillman):

Big difference, right? Even though the focus of the scene is the same, the color adds to the core concept. The past scenes are bright, with saturated (or undiluted) colors, making each panel feel like an ideal, golden-age type of scene, and the brutal present time scenes have a grit and harshness in their coloring that matches the visceral emotion expressed within them. Check out the backgrounds: in the scenes taking place in the past, it's very much two-toned colors, very flat and serviceable, but with a definite focus on our main players; the scenes taking place in the present happen in a dark alley and, thanks to the coloring, become more than just that: they're dirty, dingy, with bricks that seem like they've seen better days, and there isn't a pristine color to be seen anywhere in the scene. This way, the coloring adds meaning to the environment and makes it feel more dangerous.

How we showcase color says a lot about what its use will be, and the combination of said color with other types can add weight to a scene. Some color combinations might include:

- *Red, yellow, and blue:* Primary colors, colors of purity, virtue, and lack of corruption—environments with this scheme tend to be of an idealist nature.
- *Green, purple, brown:* Colors of corruption, greed, and mischief. You may have already noticed that supervillains, ne'er-do-wells, and bad guys tend to adopt this scheme—and their environments do so as well.
- *Purple, yellow, or orange:* Here, purple can be seen as cunning or intelligence, and the yellow elements might indicate a concept of gold or riches, making this a royal or opulent scene.
- *Red and black:* Colors of intimidation and strengths; mobsters, tough guys, and that lot tend to wear these colors, and environments that contain these usually are areas where violence or danger occur.

- *Red, white, and blue:* American patriotic colors, used to indicate a nationalistic or classic Americana scene. They can also indicate other nations and schemes (the Union Jack of the United Kingdom, for example) as well as tie characters to the values of certain ideology (Spider-Man's color scheme comes to mind).

There are plenty of other color combinations we could go over (for example, using cold colors to showcase a warm piece within an environment, or vice versa), but you get the idea. Color is open beyond the examples presented here, and you can also come up with your own combinations that each mean something specific to you. Keep in mind, however, that the way you decide to use color must complement the environment in a way that it enhances the story and makes the scene work in a dramatic and exciting way:

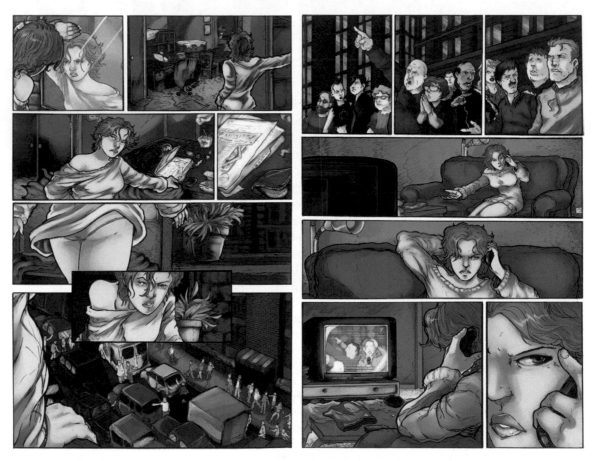

We've stumbled upon another key element in using environments effectively within a narrative: the type of mood those environments might offer a particular scene to enhance the action and create tension. Though color can do a lot towards implementing mood, there are still many other ways in which an environment can add to the conflict of a story, and they are worth exploring in the same detail as color work.

ESTABLISHING MOOD

As we've seen previously, color can add a great deal of resonance and atmosphere to an environment in a storytelling piece. However, it isn't the only way of representing emotion with your illustrations. Mood, or the inherent emotion expected from an audience when viewing an image, can be achieved in many ways, many of which we've already discussed. The way we use our knowledge of background design makes for a better mood piece.

For example, let's look at the following panel from our continuing adventures of one Felix Fahrenheit:

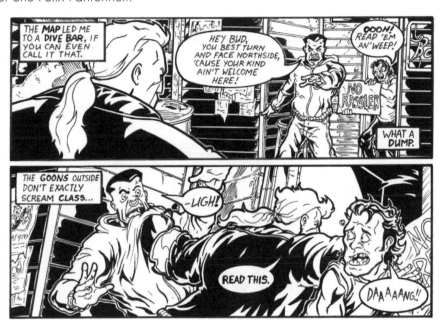

Our main character is about to enter into a shady spot filled with dastardly characters and few good intentions. But exactly how do we know this? Well, yes, because the panel captions tell us, but imagine said captions were not in place and we had only the illustrations to tell us about the place. Chances are we would still get a feeling that this particular spot is not one we would want to visit on a regular basis.

But why? Let's look at the first panel again:

Look at the way the place is lit. We have heavy shadows, for the most part, covering a lot of the background, though still keeping the environment visible enough for the audience to understand. So a heavy use of spot blacks, in strategic spots, increases the mood of the piece. But what else makes it "moody"?

If we look closer, we can also see that texture does have an impact here. Let's look at the wood in the environment here:

The texture, consisting of broken lines and half-drawn edges, makes the wood paneling look older—even dilapidated. This adds a sense of previous use to the scene, as if the wooden structure has seen better days and has been left to rot without care. The place seems even less inviting and weight is added to Fahrenheit's decision in continuing toward the structure.

Now let's look at the second panel, where we find ourselves getting closer to the action:

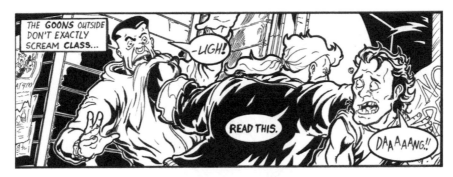

Notice how the panel is shot: It's a slight low angle shot, with a bit of a tilt, making Fahrenheit look a lot bigger and imposing in the scene while adding the visual context that he is, in fact, walking towards the bottom of the panel (the "underworld," as it were).

This is a design element implemented in the layout of the piece, adding a subtext to the scene that is not necessarily an immediate connection for the viewer but is meant to click in the back of their mind.

Finally, notice how the entrance itself is lit: the actual doorway has plenty of light, but the interior is pitch black, giving no indication what Felix will find inside the bar. If we were to view the page in full, we would see the interior of the bar in the next panel, but each shot is supposed to work on its own (think of each shot as a separate storyboard, with each leading to the next scene). Again, it adds to a sense of unknown danger within the shot and makes Fahrenheit seem braver in his decision to continue onward.

Going back to texture and line structure, you can use elements of drawing design to draw upon strong emotional reactions from your viewer. For example, if we use the following lines:

on the following surface:

we get a clear distinction between two surfaces, creating a sense of texture and a context of reality within the illustration. However, if we were to expand the image and reveal it in full:

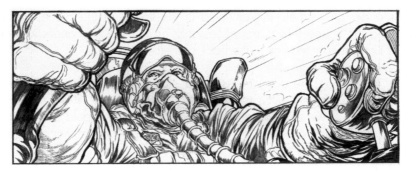

We now have the hatching elements working with other line structures to create a full image and add to the emotional thrill. The gloves, as well as the instruments in the foreground, contain higher detail and need more of a line difference to work. In fact, the character in full has high detail, as well as the surrounding cockpit instruments, giving the image an "in your face" feel, while the sky and clouds lose consistency, appearing undefined due to speed. Thus we get a powerful image that focuses on the speed of the plane and the full control of its pilot.

Also of note is the angle at which the image is being presented here. We are viewing the image at a slight low angle, very close to the pilot's hands as they grip the controls. There is a vibe of a slight four-point perspective grid here, with action happening very close to the viewer. This setup helps add to the already present feelings of action and power, complemented by the full view of the sky and top of the cockpit, and serves as a strong example of how blocking can help us develop mood in a scene.

As visual storytellers, we are as much a *director* in our narrative as any editor, studio manager, or actual director would be. We set up how a scene is going to be viewed and how we want that scene to be perceived by a viewer. That means we have to be mindful of different ways in which we can develop a shot to best use our players, environments, and all illustrative/ layout techniques concerning the two. For example, we can make the viewer feel different emotions:

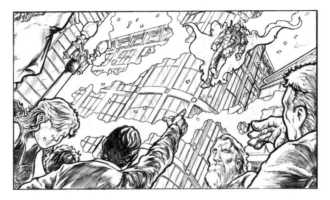

such as awe...

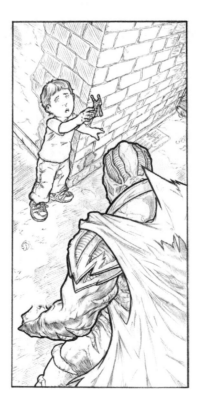

or dread...

or comfort and excitement...

as well as anticipation and danger.

You can also change the mood of a sequential scene while the piece is moving forward. Look at the following example to better understand this point:

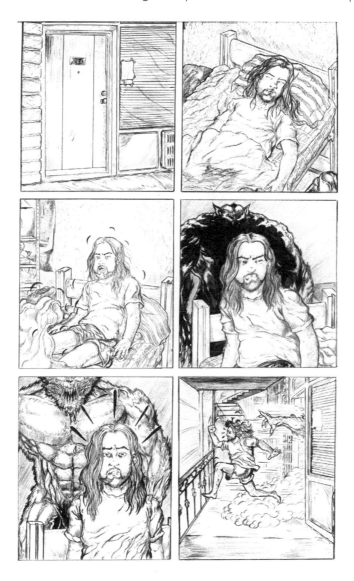

These six panels show a gradual change of mood as the piece progresses. It's supposed to be a bit spooky, which is implied by the dark tones and heavy texture lines, giving it a gritty feel (almost like an exploitation film). Notice the angle at which we see our character sleeping; he's on a slightly

canted angle, adding to his sense of confusion, yet when he sits up we return to an eye-level shot, making his disorientation appear connected to the previous visual.

As we progress through the scene, we finally see the creature that has woken our poor sap, which then leads to the finale—a humorous turn as the sap tries to escape from the clutches of his assailant in a stupid sort of pose. The background complements this concept, not so much by lightening up the mood (it's actually just as gritty as it was at the beginning) but rather by using said grit to showcase just how ridiculous the concept is. Thus, we achieve a *tonal change* within six panels that both use the environment accordingly to create a sense of mystery and then invert that very sense of mystery into something silly, while still maintaining the elements that created the mood in the first place. Storytelling with environment, folks!

Mood is a natural component of any visual. Every image, either intentionally or not, conveys a certain element of mood within its structure. In the same ways in which we use blocking, texture, and design to get the audience to feel emotion, we also showcase all the elements that brought forth the mood in the first place. This method adds the final component necessary to start creating exciting environments with solid stories. It's time now to take all these tools and blend them together into something spectacular.

BRINGING IT ALL TOGETHER

In the last couple of chapters, we've explored different ways to personify your environments and give them a sense of texture and implied reality, as well as add a mood or ambience to a scene. We've explored color in design, and we've explored shading and its effects on visual storytelling, focusing on environments. But how do these elements coexist in a particular image without clashing, and how can we maximize their effects towards an audience, leaving behind a lasting impression?

To do this, we have to come to terms with the fact that as visual storytellers, we must now wear many hats: directors, actors, stage designers, costume designers, and—important in this case—graphic designers. Graphic design is all about iconography (which we peeked at a couple of chapters ago). We are used to seeing iconography interpreted on paper pretty directly (environments tied to a particular character or vice versa), but there are many ways to actually present iconography and design on paper.

No one element works alone to create a sense of design in a scene; it usually requires many different tools and tricks to make a scene more dramatic. Take the following drawing, for example:

Here we have a simple shot of an apartment complex, viewed from far away, above ground, nothing too dramatic about it, and certainly nothing out of the ordinary. We get a sense of the focus on the scene by how it's framed and laid out (smaller buildings leading to the bigger, closer building, with visible features, though too far to be textured). The smoke and clouds are evident enough to give the scene an urban feel, yet it's likely that you've witnessed similar views from your own home or apartment, as well as from work, visiting friends, and school.

Let's look at a closer image of the apartment:

This image feels more focused, with a clear concept of the texture and age of the apartment complex. No longer are we dealing with just shapes of buildings and adjacent apartments: now we are clearly dealing with wooden window frames connected to a brick structure, and we get a better sense of how the image is drawn out. In terms of mood, it feels more intimate, but we are still outside, respecting a boundary, as it were.

However, once we get into this last image, we start getting a bit more personal.

We now get texture and structure that connects with the previous images (the walls feel like they could belong to the environment seen from the outside),

and we get bits and pieces of the window framing the image, but we have a different focus: a direct living space instead of an implied one. By this, I mean that the building itself gives you an idea of what an apartment within it might look like, but with this panel, there's no question as to what the layout of a bedroom might be.

Each image works individually and portrays a different focus, with mood, design, and layout working adequately to create full illustrations. Let's put these images together and make them part of a sequential narrative:

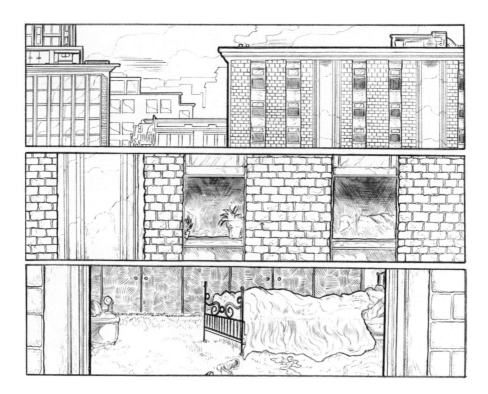

We now have a unified focus as well as the individual focus established for each image. Also, look at how the images interact with one another: because of the framing of each piece, it looks more like a "zooming" effect, as if we are focusing a lens into the general direction of the building all the way into the apartment bedroom. The mood has now changed from one concerned with establishing a sense of its surroundings into one that takes the motion of the panels into account: it's intrusive, with the viewer taking part in the action of eavesdropping on someone's bedroom. Thus, by adding these elements together, we get audience interaction and get them to invest even more of themselves into the story.

Graphic design plays a huge part here as well. Notice the very shape of the building and how it's refocused in each panel. Because of the placement of the first shot and its recurring visual construct (the walls match what we see from the first shot, just closer), this adds to the visual the notion of movement, even though these are three different panels, existing in different planes. This concept goes into that of the silhouette in design and visual storytelling:

Let's pretend that you have not looked at any of the panels reviewed previously, and this is the first drawing you see. You will probably look at this and say, "Wow—someone needs to put some windows on these buildings" and not realize that you are only looking at shapes on paper. That's because, as discussed earlier, certain images tend to become icons, and thus become symbolic to the subconscious, immediately creating a connection with the viewer and the image in which they complete the image themselves. In other words, you'll look at this and see a city, even if it's just blocks, because that's what you've been conditioned to think a city looks like.

Again, all you've learned so far is that different tools are meant to serve a constant master, which is the story. What you want to say is very important,

and how you use visuals can change the mood of a scene instantaneously, even if similar elements are present:

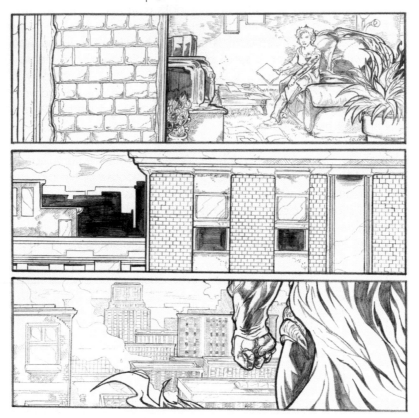

Here we have some of the same elements that made the last three-panel story work, but presented in a different way for a different effect. Where the previous images showed us closing in on the building, creating a zooming in effect, we now move away from the image (zooming out), thus projecting a completely different message to the audience (this time we go from the intimate to the grand, instead of the other way around) with a new narrative context altogether (we are now revealing a character or situation, rather than intruding into one). However, this approach works only because we are familiar with the elements viewed; we have already accepted these images as buildings connected to an apartment complex (not to mention that the apartment has become a fixed environment in our story), so the narrative can take a couple of turns and use these images, so similar to the previous example's, to tell us new information.

Again, pretty cool stuff.

Don't think that this doesn't apply to gaming or animation simply because we are dealing with paneled images. No, my friends, these concepts can

be applied seamlessly into the visual flow of animation rather easily (an environment has to be set up for the use of multiple blocking frames and shots, each connecting to one another and establishing a full narrative that can be changed, inverted, or even contradicted on screen). In gaming, we are expected to use similar environments and angles to retrieve clues, achieve challenges, or get a concept of how the game play affects the word being explored. All of this points out the importance of level maps (floor plans), texture in the environment, blocking, lighting—you get the picture.

The last subject I wanted to go into in this chapter is how these concepts complement color (in this case, gray tones) by presenting an image that uses elements of all the subjects mentioned thus far, as well as color to create a dynamic design:

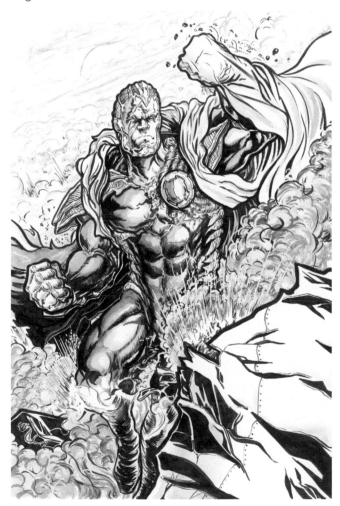

Here we have crosshatching, rendering, and broken lines complementing a gray-toned image to add the feeling of grit, texture, light, and shadow to the illustration. Notice how the gray tones are actually used for the background lines, giving the sky depth and distance, while focusing the image on the foreground features, which have the darker lines and stronger definition. Finally, we get some of the graphic design elements discussed earlier with the placement of the figure in connection with the explosions surrounding him, the scrap metal that's flying all around, and the vast environment behind it all. This all adds up to create an iconic, visceral scene that screams "power," thus hooking the viewer's attention (which at the end of the day, is what all good illustrations hope to do).

Your layout utility belt is pretty much complete at this point, and you've learned various ways in which you can use some of these new skills to present strong images. However, we're not quite done yet: next we'll take all these elements and add context to the images, see how these concepts have been used in the past, and how to best collect visual reference for future designs, whatever they may be.

Oh, and there's a bit of business still to be settled up inside a secluded bar, somewhere within a certain jungle.

Act **3**
Rendezvous Point!

AFTER SOME NEGOTIATION, I MANAGED TO ESTABLISH A LINE OF **COMMUNICATION** GOING...

THE... THE **CASTLE!** YEAH! THE PLACE IS HUGE AND AND THERE GUARDS EVERYWHERE AND AND LOTS OF WEAPONS AND AND...

... AND PLEASE DON'T HURT ME...!

SEE, THAT WASN'T SO HARD, RIGHT, BUD?

UNGH...

OH, ONE LAST THING, SINCE YOU'RE BEING SO HELPFUL ...

... YOU WOULDN'T HAPPEN TO HAVE A **RIDE**, WOULD YOU?

Section 5

Meanwhile . . .

This is it, folks! The home stretch!

So far, your job has been to better understand backgrounds and environments for use in dynamic storytelling. We've explored different layout techniques, visual cues, and design functions to add more depth into your stories using environments as the key. However, could that be all there is to it? Are you now complete experts in the field of *environmental design*, ready to take young learners under your wing and teach them the ways of layout, like an old samurai passing the torch onto an understudy?

Well...no. Not yet, anyway.

You see, you've learned a lot about the things we can do with backgrounds, but you don't necessarily know where or how to use these skills outside of your regular, comic/animation/gaming framework. You must also understand how these concepts have been used in the past and how some previous art movements affect the way we visualize interesting environments for storytelling. In short, you must gain a little . . . perspective, as it were. (See what I did there? Yikes!)

The time is coming when you'll be put to the test. Yes, faithful reader, you will be pushed to your artistic limit; you will go to the ends of your own imagination and produce stunning environments, all in the name of pure storytelling! Think of the excitement! Think of the thrills! Think . . .

Oh, stop looking so worried! It's going to be fun!

ARTISTIC WORLD VIEWS

As a storyteller, you have a *vision*. This vision is unique to you and you alone. By this, I don't mean that your story might be the most original piece of narrative ever written, because it's probably not. Let's face it: most stories are, at their core, a retelling of classic themes that existed long before you and I set foot on this earth.

In reality, it's your personal interpretation of these themes from which we get the originality, the vibrancy, and the excitement of the "new," as well as how you visualize these themes and how you bring them to an audience. It is here that we tend to find that concept that rears its head every time a young artist shows me a piece of work and claims it as his/her own, though it may be as common a concept as the sunset—and that concept is *style*.

Style gets connected to a lot of superficial elements that, in all honesty, lose the point of the full concept presented. Let's take the following two images:

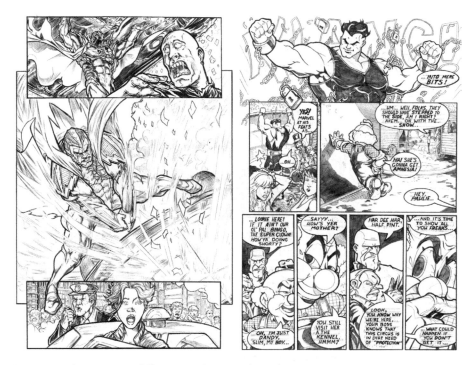

Here we have two different styles employed to represent an action piece. The first set of panels shows off a dramatic moment in a story involving super-human characters in a somewhat realistic world. Because of this, the subject matter dictates a harsher, more realistic take on the proceedings, with the use of hatching line, texture, and broken line weight adding to the overall "real world versus fantasy" mood of the piece.

The second set of panels displays a story set in the world of the circus, filled with clowns, stunts, and strongmen. Here, the style employed is cleaner and more design oriented, letting the imagery create most of the notion of iconography, rather than creating texture for a realistic feeling throughout. You can also see that the comic is meant to feel more youthful, as if both kids and adults are expected to enjoy the book together. The first piece is aimed toward a more mature audience, and the violence seems less cartoonish because of it.

So what can we say about style after viewing these pieces?

First off, as touched upon earlier, style is meant to define the way an artist views the world and how said artist interprets it on paper. It's also important to understand what exactly is being interpreted, for whom it's being interpreted, and the main points that the style must address so that it can come across clearly. To expand on this concept, let's look at both of these image sets with a bit more detail, starting with the first two panels from the first page:

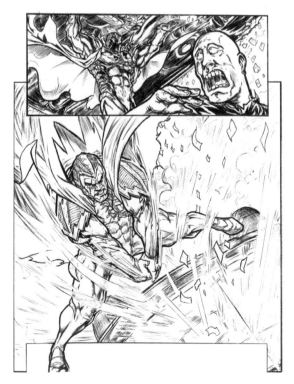

Here we have a supernatural character holding a big van, right before he throws it upon a poor criminal (not so poor, really, if you read the whole story), as well as immediately afterward. What makes the scene feel powerful is not just the superdeveloped muscle structure of our main character, but also the fact that he's holding something that most of us would find recognizable: a van! We've all either seen, been in, or driven a van at some point in our lives, and because it's drawn with an eye to detail, we get a sense of the sheer weight and mass of it, making the impact of the actual plunging of the van onto the culprit seem the more powerful.

In contrast, we have the following panel:

Here, the scene has more whimsy to it, so the imagery has less to do with how "real" it feels and more to do with how fun it looks. Yet all elements viewed in the scene are still recognizable to the viewer (the ground has some level of grit, also the crowds and the stage are very clearly defined). They are clear enough that a younger reader could identify them readily, which in turn brings the reader into the story, even if there are parts that he/she might not understand. (Remember the drawings of a house we viewed at the beginning of the book? This follows the same concept: kids get what the main concepts of "look" and accuracy are, even if they still can't express them clearly on paper. Maybe they can't draw perfect houses, but they sure do know them when they see them.)

Style should help the viewer connect with the story. What else?

Okay, we could also say that a versatile artist might want to find a way to employ a style that is *versatile* as well as *identifiable*. Think about it—if your style is too consistently gritty, you might be closing the door on work that might be lighter in nature, with the same happening if you have a style that is

just way too cartoonish. You could find a happy balance or try to fit elements of your drawing techniques to serve a particular subject matter. Let's use the following two pages of the "Exit" comic strip as examples:

As I've mentioned before, these pages are part of a story that uses two particular styles within its storytelling: scenes set in the present have a grittier,

more rugged style, and scenes taking place in the past tend to have a cleaner, more graphic style. The idea here is to present two different states of mind: the perfect "golden" days of yesterday versus the compromised and corrupt world of today. Because of this constrast, the environment must not only represent these concepts but also enhance them. Let's take panels from each style to explain this. We begin with a panel in the present:

Here we have a dark alley, perfect for a beatdown, with our main character poised for one. Look at the alley where our characters stand: cracks on the walls, rigid bricks, strong shadows, and limited "film noir" lighting. The style

therefore complements the feature and allows the action to feel dramatic. Then, we have the following image:

Here we have a classic superhero, clean-cut and smiling, standing in front of a metal wall that seems to be part of some future-type environment (even though it's the past…yeah, I'm confused, too). Notice how clean the lines are throughout and how well represented the environment is with minimal line work. This is because, again, the style fits the subject matter, even if it's the same one employed on the panel before last.

However, let's take one more look at a panel from "Exit":

Here, we have a *blending of both styles*, with the characters appearing in a style somewhere between the present and past representations because the context of the scene demands for it. Thus, the fluidity of style doesn't pertain just to what an individual project might need within a project but also to a particular scene or stage within it. For a film example that showcases how color and mood affects an established style in a piece to the point of almost changing its focus, look at *The Incredibles*: the beginning of the film is colorful and golden, the middle is bland-looking and muted, due to the lack of superheroes in the world, and finally, you get a blend of the two at the end when the heroes learn to balance family with adventure. Thus, we have multiple visual styles used in one project. Projects such as *Kung Fu Panda*, on the other hand, clearly display a stronger change of style that has a direct impact on our perception of a particular scene, with the beginning of the movie animated in 2D format, establishing an idealized past, and then switching to 3D to represent a modern reality—or relative reality, anyway.

The final word on style is that it really is something that is *personal*; therefore, it will grow with you as you mature, not only as an artist but also as a person. You shouldn't get married to one particular style or even one particular medium; you may find that the more versatile you are as an artist, the more you'll find work that will fit with your various aesthetics. Just remember that as much as character types change, their backgrounds also change with them.

THE ART OF ENVIRONMENTS

Every artist developing a style will at first be subject to influences. You'll see a character you like, or an artist you admire, and—to learn the ways the art works or the rules of the figure—you'll either copy the style completely or mimic some of the elements. It's okay; we've all done it at some point.

The way style should develop is that we should incorporate some of those same influences, and through them, find our voice. But one thing that we tend to forget is that our very same influences (those artists we tend to admire so much) themselves had influences of their own, as did their predecessors, and so on.

Background design is no different. The way we've visualized worlds on paper has been affected by a multitude of art styles and art movements, each taking something from its previous exponent. To give you a little background on this concept, the following sections discuss some of the architectural and artistic movements that have had a direct effect on environments within the world of animation, game design, and sequential art.

Expressionism (German)

Take the following image:

This is a classic piece of old-school "creepy": an environment that we've come to expect in some horror films or comics, that would symbolize "danger" and "terror." This type of shot or feel comes courtesy of Germany through an art movement known as *Expressionism*. Belonging to the late 19th century, its biggest influence on our social consciousness came in the 20th century through the early works of silent film masters such as F. W. Murnau (who made, among other films, the first unofficial Dracula film, *Nosferatu*) and Fritz Lang (creator of the sci-fi classic *Metropolis*). These films employed certain elements that have found their way into the media arts and are synonymous with horror: long shadows with jagged angles, broken perspective shots, canted angles, and very striking lighting are some of its more common features. You can see these types of images in a multitude of modern cartoons and games. Scooby Doo employs a more playful version of this, and shows like *Batman: The Animated Series*, *Darkwing Duck*, and *Gargoyles* used to use it in a more striking fashion. The *Resident Evil* games, *BioShock*, and both of the *Arkham* games use it to great effect; any horror film in existence employs elements of German Expressionism almost constantly.

Art Deco

The more science fiction–based elements of German Expressionism used some elements of another modern art style known as *Art Deco*:

Art Deco is an art movement, established in the first half of the 20th century, involving different art styles (*Cubism*, *Expressionism*, and *Futurism* are a few of them) to create a vision of an industrial future world. This is where we get our skyscrapers, as well as our city silhouettes and skylines. If you notice, all the buildings designed as part of this movement tend either to be layered upward to a literal point or to have certain elements that look like they are reaching upward (the movement is supposed to scream "future" all around, as if the industrial age has opened the doors to technology—which it did, come to think of it). Any show, cartoon, comic, or game that occurs in a big cityscape or in a future world that is industrialized tends to be heavily influenced by this artistic movement, so check out some examples yourself.

Art Nouveau

An art movement tied to 19th-century Expressionism, *Art Nouveau* (meaning "the new art" in French) is very much a contrast to the strong, sharp lines of both Art Deco and German Expressionism:

If you've seen *Cinderella, Beauty and the Beast,* or (in contrast), *Bram Stoker's Dracula,* you'll see some of the elements of this graphic style: spiral staircases, long, fluid lines, and a smoother texture or color palette. In fact, the works of some Art Noveau artists are some of the most commonly recurring sources of influence on a lot of our modern graphic artists (Alphonse Mucha is one of the most prominent artists tied to this movement, and his influence can be seen in the works of such modern illustrators as Adam Hughes, Arthur Adams, and Mike Mignola, to name a few).

Bauhaus

Bauhaus (from Germany—the Germans sure seem to come up a lot, don't they?) is an architectural movement born in the early half of the 20th century that involves very simple, geometric figures used to create visuals that are practical, usable, and iconographic:

Bauhaus is about functionality, taking the most rudimentary of necessities and interpreting them to their most simple of forms (very much like what cartooning does, really). You see its influence constantly in cartoons and games, even when the imagery is meant to emulate something else (*The Simpsons,* for example, is supposed to emulate Americana, but the geometrical style employed throughout, as well as the simplicity of the pieces used in scenes, reveals a Bauhaus influence).

By no means am I saying that these are the only architectural movements that have had a direct influence in animation in modern times. *Gothic Architecture, Modern,* and *Postmodern* art styles—and whatever is happening outside your window today—are just as influential as Bauhaus, Art Deco, Art Nouveau, and Expressionism. But these four are the styles I encounter in most media art work.

However, don't just take my word for it—study and research each of these art movements. Each one has its own forebears and influences, so it would be wise to look those up as well. This type of research is important to the

developing artist and will provide multiple images from which you can get inspiration, finish projects, and develop a solid morgue file for yourself.

What is a morgue file? Funny you should ask!

MORGUE FILES AND THE CONTINUING ARTIST

In previous chapters, I've said that research (*RESEARCH!*) and reference work (*REFERENCE!*) are both extremely important in the growth and development of the continuing artist and should not be considered "cheating," even if your peers at school or your friends might think otherwise. Simply put, there's just no way you can depend on your mind alone as your only point of reference, if for no other reason than because you have a limited amount of experience (you are also limited by your point of view, culture, social class, geographical location…).

However, we've discussed research only in terms of one assignment at a time. Though serviceable to you for the completion of a project, this is limiting because it responds to only one situation at a time and might not lend itself to future projects or concepts. Also, as an artist, you may find an image, either online or in a magazine, that is visually interesting but might not fit any particular commission you might have at hand. Should you just forget it and move on?

No, obviously. That, fearless reader, would be a dumb thing to do.

With this, we enter into the magical world of morgue files. A *morgue file* is essentially a library developed by artists that is filled with interesting images

and photographs that, despite not being essential for any current projects, could eventually serve as a reference for a future assignment (the name alludes to an actual police morgue files, which kept old documents from specific cases that might eventually be of some use). It may also contain sketches of abandoned ideas, doodles, half-drawn images, or established reference for a project that never got made.

Take the following images an example:

These are photos taken around Arlington, Virginia, on some random day. They were not directly meant to be reference material; they weren't taken with any environment in mind, or with a given purpose. They're just images

taken randomly of a populated area. But they served me well when doing pages like these:

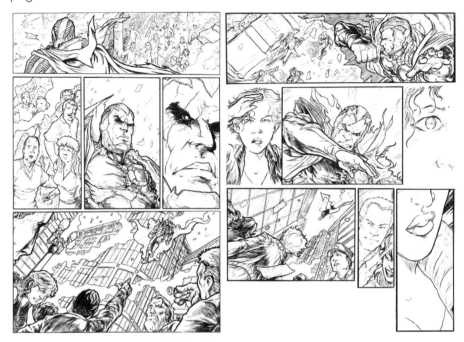

Mind you, the images are not directly referenced, but they allowed for a good starting point for some of the shots being developed within the story, and they helped reduce the time the story took (after all, we are constantly dealing with deadlines in this industry). For example, if we were to take one image and place it next to a sketch of one of the panels developed for the page:

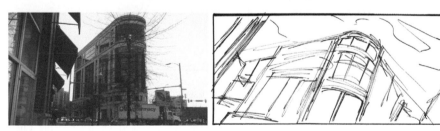

You'll see that the drawing is not entirely representative of the photograph used. They have similar layout techniques, but the actual shot is significantly different. That's because I had an already established set of reference points and shots that I wanted to use for this image to tie it to the rest of the narrative. However, I was not satisfied with the actual shots I had collected, so I decided to use different layouts to advance the story, which reminded me that I had images lying around waiting to be used!

This example brings up a proper point in the use of research: *don't get married to your reference!* Research is meant to serve you as a guide, not to dictate the look of the image. To answer a query that has plagued mankind since the mid-1980s, *you* are the boss! Let your reference *serve* you rather than dominate your illustration.

Another example is a commission of mine based on one of the images viewed in this book, the "Barbarian King":

The request was to create an image that used the concept of the Barbarian King character but made it look as if the character had gone through some form of demonic possession or had a supernatural sort of look. The client also wanted a different pose, one that still made the character look regal and the environment look ancient, but in a different context than the original piece.

If you've ever had to rework any of your pieces, either for an art class or for any commission, you know that this particular request can bring a certain

amount of anxiety. How do I reorganize the image? What do I do with the character that I haven't done before?

And then I realized I still had these:

"Aha!" I thought. "I'll just use one of the concepts I didn't develop earlier, and push my assignment that way!"

I decide to use the image with the warrior sword placed on the side, mostly because it's quite different from the original, yet similar; also, because the image makes the character look less pensive in posture and rather more aggressive in nature. From there, I did a light sketch, incorporating some of the elements I wanted to incorporate:

Using some of the research done earlier, as well as some new looks for texture and line structure, I rendered a final piece:

Boom! It's now a piece that definitely holds a connection to the original, yet has its own identity and purpose. A successful image overall, thanks to images that could have easily been discarded earlier as failed attempt (you might be surprised how often this happens).

Morgue files have also grown in terms of their scope of possibilities thanks to that ever-present source of unending information: the Internet! Seriously, there is no end to the amount of images that you might have access to with just the Web. Also, programs like Google SketchUp, which offer sample layouts as well as the ability to set up your own grids and virtual layouts for reference, can help you visualize how certain elements might work together in a scene. However, keep in mind that all of these tools can serve you appropriately only if you already have a proper understanding of layout design to begin with. No amount of reference can substitute knowledge, and you must understand what you are doing in order to use the tools provided in this chapter and throughout this book.

Your central idea must guide the full production of your artwork—a point I expand upon within the next couple of pages.

FORM AND FUNCTION

References, tricks, and grids will always serve you well as both a designer and as a storyteller, but they mean nothing if you don't understand how and when to use them.

In previous lessons, you've learned about finding the focus of a scene, both as a theme and in terms of layout, and exploiting it for a heightened connection with an audience. However, as I've seen over and over in some classes, we tend to get a little wrapped up in some of the drafting features we'd like to attach to our images; so much so, in fact, that we forget what the image was about in the first place. Take the following example, an image illustrated by me in a more innocent time, for instance:

I can't stress this point enough: *DON'T DO THIS.*

The crosshatching and the line weight, though seemingly dramatic and enticing, actually get in the way of the actual texture work, keeping us from connecting to the visual at hand. Also, when you overtexture an image, you tend to blend pieces together that should be left to stand on their own, thus making everything just one big ol' mess. (If everything has texture, then *nothing* has texture. We'll come back to this point shortly.)

Still, I can understand the mindset required to produce something like this (after all . . . I produced it . . . sigh). I wanted the image to look cool, like the many pieces of art I've seen in comics and animated films, but I focused only on the details and didn't see the big picture.

The big picture is this: *form* (the way we render an image, lay it out, and stylize it for an audience) always follows *function* (the purpose of the image and the reason people will be interested in the first place). We've covered a version of this concept in previous chapters, but it not only bears repeating: it requires full analysis and comprehension.

Let's set up some rules, so that my plight as a young adult might serve a higher purpose than just having drawings at home to point at and laugh (don't get too cocky, friend . . . I'm sure you have some of these as well).

- **Find the purpose and focus of your piece.**

We've covered *focus* in other chapters at length, but it's never a bad point to repeat. Let's take the following illustration as an example for study:

This image for the Dark Legacy card set, called "Breeze Knight," showcases a type of wind riding character, dynamic in posture, with the elements surrounding him as he glides. The focus of the piece is power and fluidity, and the character evokes these concepts rather clearly. Notice that the hatching elements throughout the figure are wavy, showcasing a sense of cloud currents and wind throughout.

Still, the purpose of the piece is to create an image that will be included as part of a tabletop card game. That's it: it's just that simple. Yet sometimes that very concept can be the first thing we tend to forget when creating images for a specific medium. Not only that, but the purpose of the piece will dictate how the focus is represented—thus both concepts must remain tied together.

This leads us to our next rule:

- **Know your medium.**

Different products require different approaches. Take the following image from our long-standing narrative as an example:

Here we have the lair of our villain, viewed from the interior of its stronghold. The image shows some level of detail work, visual narrative, and enough dynamic elements to keep the audience member invested in the piece. Of course, this is intended to be part of a collection of illustrations, a comic book story in which the production time might allow for the type of detail work that could really liven up a story (once again, focus—show a powerful scene—and purpose—periodical storytelling—work hand in hand).

However, let's take the following short strip as another example:

Here we have the language of the comic strip: three- to four-panel short stories delivering a beginning, middle, and end in a short frame of space, meant to be read on a daily basis. Because of their delivery schedule, comic strips tend to employ a very stylized, simple drawing structure meant for quick production and immediate turnaround. Take a look at the environments used in these panels: they are readily recognizable and have a strong silhouette, with a clear sense of iconography in terms of design.

Sounds a bit familiar, I take it. That's because that is the same design aesthetic that we employed earlier with the Nick Kringle concept, which was one meant for animation. In most animated pieces, production times are actually very tight, so the conceptual design employed tends to be iconographic, with a lot of its visualization going into the iconic versus the heavily detailed (besides, that's a lot of drawings that you have to repeat in order to get one piece of animation off the ground, and it's a lot harder to produce an animated piece if you have to worry about heavy detail).

Finally (at least for this point), let's use yet another card from the Dark Legacy card game:

With this card, we are now dealing with a completely different context yet again: the single image. For all intents and purposes, this card could very well be a piece of pin-up or cover art, with only one shot at telling a single bit of narrative. Because of this context, we can value detail a bit more, and we can also see how the actual piece works as a whole in one fell swoop. Reference, though important to every single one of the previous illustrations, takes on a different purpose here: we have an image that values a bit of a sense of authenticity for which we want to see actual texture (or the illusion of it) at work. In contrast, the first image required reference to keep a sense of consistency (being part of a longer narrative), and the comic strip required reference for a sense of iconic identification (cartooning, as it were).

This last figure also raises our next point:

- *Cool* comes from *good*, not the other way around.

Let's take another look at our card illustration.

The concept for the card is the "Dark Knight," though as you can see, it has nothing to do with any caped crusader. Rather, the image is of a ghostly, almost demon-like, knight character, complete with sword and shield, lunging at the audience member in a dynamic, foreshortened pose. There is, of course, a background behind our character, but it serves to showcase our character, as well as frame him in a way that delivers the highest impact to the viewer. This design, combined with all the armor elements, the texture added to the piece, and the dynamic nature of the concept itself, make for some *cool* visuals overall, but these elements would mean nothing if the central concept was not realized throughout. Thus we have arrived at the concept of *good*.

In this case, when we refer to *good*, what we are talking about is just how much our image connects with the central concept it's trying to represent. As we've said before, all elements in an illustration, a piece of sequential art, or any other types of interactive storytelling must connect and push forward the narrative being represented; therefore, all of our visual tricks and eye-catching detail mean nothing if they betray the core concept behind the story presented. Let's look at one more card that will further illustrate this point:

You can't have a book about art without some zombies, I always say. Here we have some of the living dead approaching the audience, being all creepy and stuff, while again being framed by a light background (this time establishing some dry terrain and two moons, or maybe planets—you, my friend, can decide). The way the environment helps the piece is by bringing forth its original conceit: dead characters on a dead world. The ground, therefore, has a lot of texture and grit, but no sign of vegetation or life whatsoever. It's also rough terrain, with creatures popping out from different corners, each hungry for...the viewer, actually. Again, all these elements combine with the characters in the scene to create an interesting visual, but no one element can replace the any others within the piece: they all need to work together.

Within this section, we've seen multiple art pieces and different uses of layout to enhance the storytelling required. These pieces each have an individual purpose and focus, meant for a certain pair of eyes, even if they can be enjoyed by many. The worst thing an artist can do is attempt to please everyone at once, so we must be mindful of exactly who it is we are speaking to

first and through that interaction perhaps open the door for other audiences to check our work out (think of it this way: the "zombie" piece wouldn't perhaps be the best piece to show a child, but if it connects with your intended audience with any particular heft, eventually that child could grow up to become part of your audience, keeping your work relevant throughout a longer period of time).

And so we arrive at the final rule in our list:

- **Know your audience.**

At this point, we've come full circle in our continuing conversation about environmental design. However, you've still got a little work to do before we get to the end of our journey. After all, once you've committed to a (lesson) plan of attack, there's really no turning back.

Just ask Felix Fahrenheit:

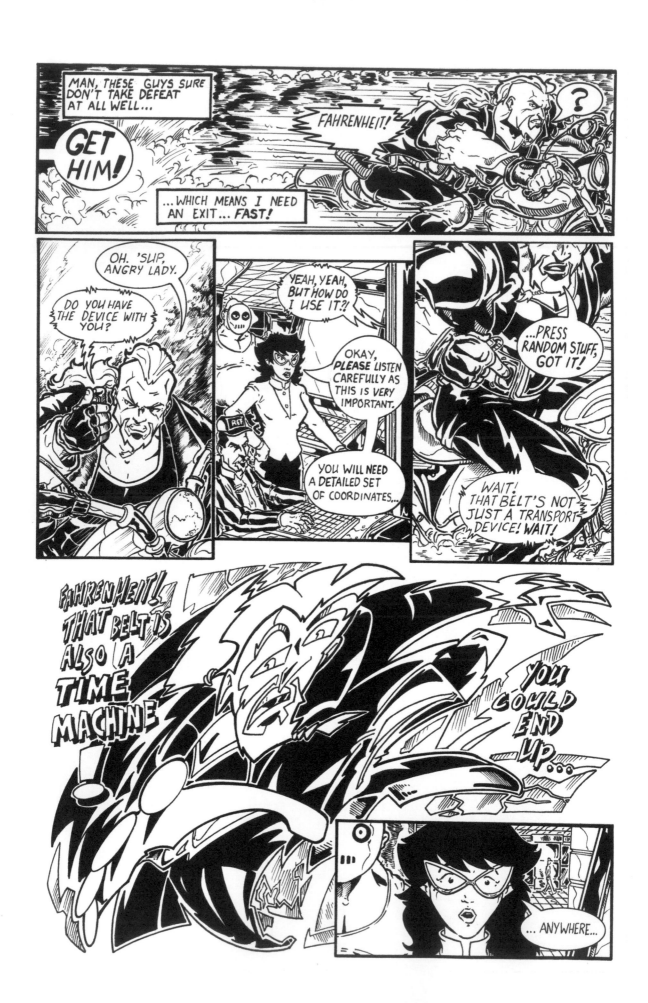

Section 6

Scene of the Crime!

We've talked about layout. We've talked about design, we've talked about composition. In short, we've talked about a *lot* of things. Analysis of theory is extremely important when learning new skill sets. Yet we haven't spent a lot of time actually working on some of these concepts with an actual project, taking it from beginning to middle and end.

In the following pages, we will take an assignment you might find out there in the professional world and follow it through from the start all the way to completion. You'll get to see how all the concepts that we've covered in the previous chapters have an effect on our project and how a better understanding of environment study and layout design can go a long way in the completion of a successful assignment.

We'll also go over some tricks and shortcuts that can help you expedite the creative process and thus vanquish those dreadful monsters that are the bane of every professional artist: *deadlines*! Finally, you will be offered the opportunity to take a project on yourself, practice what you've learned, and create dynamic and exciting images for an eager audience to gobble up!

The time for talk is over, my friend! Let's get to work!

ESTABLISHING PURPOSE

Here's the situation: you've been hired by an Animation Company ("Happyface Productions" or something to that effect) to produce pages for a new concept they are hoping to develop for their fall schedule. The concept:

Nick Kringle, Man of Xmas!

The idea is that, to create a concept outline for animators, they require visuals connected to a short script based on the production (a couple of pages of sequential illustrations telling an introductory story connected to the characters and the world they live in).

Your mission (which you've already accepted because they are paying you) is to create a new environment based on the concept and develop it for use in a piece of visual narrative to better represent the feel of the show.

Ready?

Cool! The following is the first page of the Nick Kringle script.

NICK KRINGLE: MAN OF XMAS

Episode 1

SCREEN 1

Panel 1: Long shot of the interior of a classic, rather aged-looking library hall, made up of racks filled with books of various sizes and

lengths. On some of the books, particularly festive titles like Jingle Bells *or* The Night Before Christmas *should be emblazoned clearly, along with perhaps more mundane literature like* Toy Factory Conduct Guide *and* What Every Elf Should Know. *The hall is lit by candlelight, which is placed on a table in the foreground, also filled with books and the like (some of those titles should be in the foreground as well). Behind the table sits an old elf with a long beard, drooping elf ears, glasses, and a big frumpy hat. He seems to be writing in one particular book while addressing the viewer with a smile.*

Old Elf: Hmmm hmmm . . . ahem! Dare I say, you've strayed from the normal tour, haven't you? My, what clever boys and girls you must be. And you're in luck! For this is the fabled Library of a Thousand Tales. And as we speak, I am at work writing down yet another adventure!

Panel 2: Closer on the old elf, as he motions to the viewer, pointing upward as if making a point, but still quite cheery.

Old Elf: Not a lot of people truly visit these halls up here in the North Pole. Everyone is too preoccupied with toy machines and festive cheer. But you want a story, don't you? And not just any story either . . .

Panel 3: Similar shot, but now the old elf, is picking up a book and dusting it off a bit. The book is thick and a bit worn.

Old Elf: There are many yarns about the Jolly Old Man, aren't there? Tales of cookies and milk, magical reindeer, and good ol' Christmas cheer . . . um, a bit dusty, sorry.

Panel 4: In a bit closer as the old elf is about to open the book, the lighting not quite letting us read the inscription on the side. The old elf still smiles, but gives the viewer a knowing look over his glasses.

Old Elf: Well, rest assured, my little friends . . .

Panel 5: Closer still, as the old elf opens the book, hiding his face. We can now see the inscription on the side of the book, which reads simply "XMAS."

Old Elf (in caption): " . . . this is *not* one of those stories."

Ah, riveting! I can hear you already making the following statement:

"But, Mr. H! That scene didn't even include Nick Kringle in it!"

Yes, you are right. You see, even when we are dealing with a designated concept, one that you might even be comfortably familiar with, it can sometimes be difficult to separate the visuals predetermined for the characters and concentrate on the world itself. In this case, I am introducing the concept without the main character making a direct impact at the beginning of the story, thus we are left with what's on the page, and what we already know about our subject.

Okay, then . . . what do we know about the subject?

We know the main character looks like this:

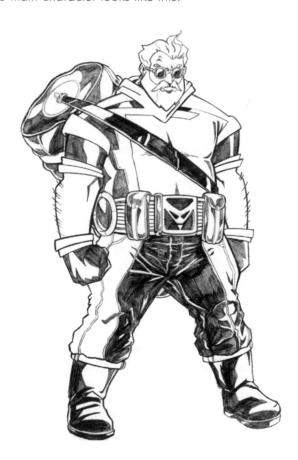

We also know that he drives this:

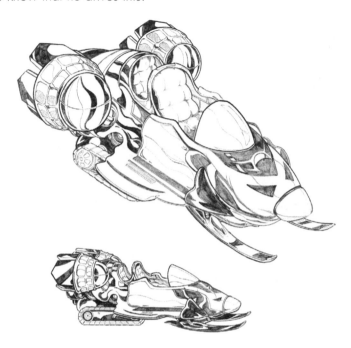

We know he lives in a place like this:

Finally, we know the type of environment he hails from:

These illustrations are now our guides in terms of what the look and feel of the concept should be. They should also reinforce the focus of our subject as well: "Action/adventure, kid-friendly, high concept."

With this information in place, we can tackle the task at hand: how do we take the narrative of this page and connect it with the concept established previously? Also, what is the individual focus of this scripted page, how do we make it reflect the overall concept, and how do we use layout to better represent said scene/focus?

In this chapter we will explore these questions and work on these images together, taking what's written and giving it life. Through this process, you will hone your design skills and perhaps learn some new tricks along the way.

Keep in mind that this is how *I* do this process. You'll find that other methods might fit various subjects differently, and perhaps you and I might have different ways of visualizing our subject. That's not for me to decide—that's all on you. However, I want to show you that these methods work and that you are well served by a full understanding of design and layout when dealing with these types of assignments.

All right, we have our mission! Let's get started.

CREATING STOMPING GROUNDS

Let's break down that first panel of our script, to better get a sense of what our task is going to be:

> Panel 1: Long shot of the interior of a classic, rather aged-looking library hall, made up of racks filled with books of various sizes and lengths. On some of the books, particularly festive titles like *Jingle Bells* or *The Night Before Christmas* should be emblazoned clearly, along with perhaps more mundane literature like *Toy Factory Conduct Guide* and *What Every Elf Should Know*. The hall is lit by candlelight, which is placed on a table in the foreground, also filled with books and the like (some of those titles should be in the foreground as well). Behind the table sits an old elf with a long beard, drooping elf ears, glasses, and a big frumpy hat. He seems to be writing in one particular book while addressing the viewer with a smile.

To start off, we might want to determine exactly how our character is going to look in order to fit the environment we are about to create. We've got a pretty decent description, so let's just go ahead and get a sense of who this old elf is:

We've already discussed just how important character interaction is between the environment and those who inhabit it, so figuring out who this gentleman is will better help us understand our environment. From this image, along with the previous paragraph, let's break down some basic attributes we can connect with our figure:

- *He's old:* Though it's mean-sounding, hear me out. His posture, his beard, and is general demeanor presents him as a character that perhaps has lived many centuries; also, clothing, though layered and bland, adds a sense of age to the drawing.
- *He's wise:* It helps that books surround him, but he is also drawn with a sense of history to him (it's possible to create an older character and make him seem dumb, but in this case it seems that this age and personality are pretty tied together). His sharp features also give him a sense of malice (though not necessarily in a negative way), as such features tend to be present on cunning, knowledgeable characters.
- *He's hidden:* He seems to be stuck behind piles of books, and his size keeps him from seeming intimidating or dangerous.
- *He's nice (or seems to be, at least):* He seems welcoming, and he doesn't necessarily have a threatening stance to him. He's also smiling, and not an evil or alarming smile at that. He seems happy to greet the viewer.

I'm sure we could go even further than this and really explore the character's deepest personality traits just by looking at his choice of dressing garments, but this isn't Psych 101, folks, so let's move on.

Using what we've learned about our old elf, let's look at his relation to his surrounding environment. Again, as discussed earlier, environments always complement character, whether it's a direct complement (Batman and Gotham) or an opposing complement (the Punisher in Riverdale). Here, we get the feeling that the environment will complement our character directly, and as such, we can make the following assumptions about it:

- *It's old:* The place should feel as if our old elf has been working within its walls for centuries untold, and it should reflect his fragility and almost decrepit demeanor (or the illusion of such).
- *It's wise:* It houses knowledge, after all. This also connects with the previous point, seeing as how, because of its age, the tomes contained within it are assumed to be ancient as well. Finally, the candlelight makes us think that there are probably no electrical outlets to be found, as it's a very old structure.

- *It's hidden:* If you read the dialog connected with the descriptive panel, you'll see that this is a room that is rarely visited and is hidden from the general public, making it mysterious in nature.
- *It's nice (or seems to be, at least):* Though it's not heavily lit, which might make it seem mysterious, the choice of books, all festive holiday themes, add a lighter mood to the piece, making it feel more inviting and friendly.

You may have noticed that all of these attributes are pretty much equal to the way we perceive the old elf. That's because, in this case, it seems the background's personality is connected enough to the protagonist of our scene that they are almost interchangeable (with the key character trait being that of an old friend—someone who is not threatening, but holds a lot of knowledge).

Next, we need to start thinking about how to best convey this environment on paper. There are generally two ways to go about this: we can start doing both research toward design and then do some blocking in thumbnail form, or we can go the other way around and start from a blocked-out scene and do research to serve each individual scene. Depending what format you are working for, each has its own merit, but I am taking the first approach, as it sets up research that we can come back to in order to expand our environment. This is generally the best approach toward animation and level design, as they tend to take into account the fact that the environment will have multiple uses, not just in one part of the narrative.

So, off I go, with my trusty camera in hand, taking pictures of bookstacks:

Maybe mess around with the layout:

Take into account lighting and texture:

And then take into account available space, texture of environment, and our best idea for how these shots should work:

With these photos, we can start figuring out what our environment is going to look like. First, let's get an idea of the size of our environment and our playing field by drawing a floor plan for the piece:

Using this floor plan, as well as the notes we've taken and our research material, let's draw a couple of very rough sketches, each with different options as to how we might envision the scene:

Notice that these shots are all somewhat aimless because they don't take into account perspective lines or grids but rather only the emotion that we want to convey in this piece. From here, using research and reference, as well as a clearer road map of what it is I want to achieve with my environment, I can now move on to the process of actually designing the environment for animation/design purposes.

Okay, I can see that you are a bit dubious: "Seriously, I have to do *all that*?"

Here's the thing: this work actually makes the rest of the process easier. No, really. I swear.

I've tried so many times to just start working without an actual road map of where I want to go with a particular illustration, and I've *always* returned to this tried-and-true method. Yes, there are shortcuts you develop and methods of gaining research material do differ (morgue files, for example, as well as that blessed of tools, the Internet!) but the process has, for the most part, remained the same. Anyway, here's the chance to see for yourself.

CONNECTING ALL THE PIECES

We've got our research material, we've got options for a design, and we've got our concept pretty much clear in our heads—*it's now time to draw*!

First we have to decide which angle works best for this concept. In this case, I feel that the head-on piece captures enough information that we get a sense of the environment, so let's start with a one-point perspective grid and establish where our back wall will be, as well as the length of the side walls for the room:

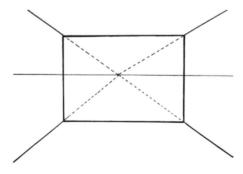

Now that we've blocked out the room itself, let's look at our original sketch:

Here we see that the elf's desk will be the center point of this environment, and all panels and bookcases lead your eye to it. Thus we need to start laying out where our table will be:

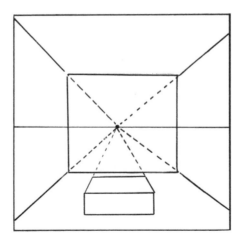

Let's use this blocking piece to better place our table, securing our leggings and figuring out the full scope of its size. Also, we should establish the back bookcase so that we can understand just how far the table is from the bookcase itself:

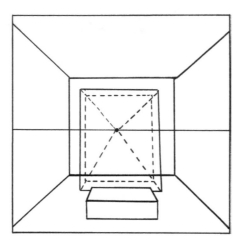

The space seems small, doesn't it?

Going back to the idea that the room itself is hidden from the general public (its age is perhaps infinite, and it holds secrets beyond comprehension), I assume that this place would be cramped, a bit small, and filled to the brim with all kinds of old books and collections. Because of this concept, I decided to place the back bookcase closer to the front table, making the space surrounding our character seem small. We can also place a couple of bookcases closer to the sidewalls to cramp the space even more. Within our allotted space, let's draw lines corresponding to the space on each side of the walls to lay out facing blocks:

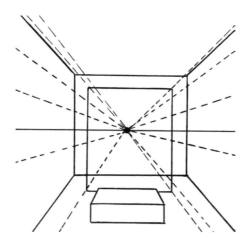

Next, let's map out where best to place these bookcases in our image. First, let's take one of the sides and draw a big X on the spot at which we wish to place our first bookcase. This X will serve not only to mark the space at which we want one of our bookcases to be, but also to help lay out the space of the environment itself and the relationship between objects and the wall:

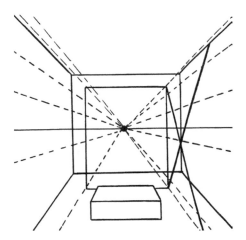

Using this *measuring point*, we can now decide where the best spot for the next bookcase should be. I, for one, think the bookcases should face each other directly, so let's block the area required and mark down the length of our pieces:

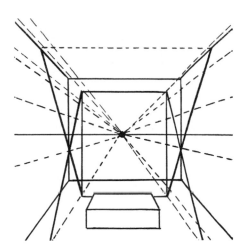

To finish off our blocking, let's draw two boxes within the space allotted from each side. In the end, our environments should have equal-sized boxes on each side, both leading to the background and both ending near the back table established in our previous images:

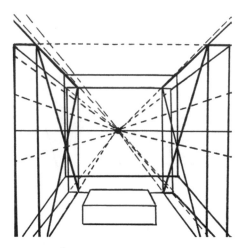

The same way we've used the X marks to figure out where our bookcases will be can also be used to set up how we place other elements within the piece (say shelves, for instance):

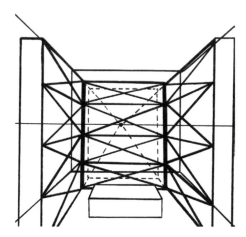

We've now got most of our space spoken for, but where are our stacks of books? That's going to require more blocking, and more boxes! Let's start with the desk: we'll place a couple of boxes (of different sizes) on the table to represent the stacks of books required for this scene:

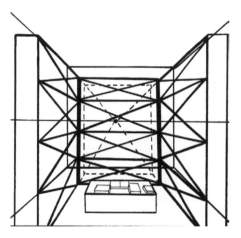

Next, let's place a couple of similar boxes surrounding the desk, where other books might be located. Remember, we want to leave enough space for someone to walk through because (a) our old elf might have to leave his desk at some point and (b) the whole point of the scene is that someone will be walking toward this character to engage him directly:

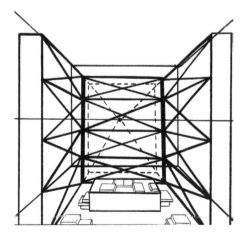

So now we have our blocking pretty much done, I think. It's time to start using some of our reference material:

With all these pieces, we can now draw out a line art structure of our full environment. We could go ahead and draw a very clear version

of our piece, using all the elements we've established, and create a serviceable image:

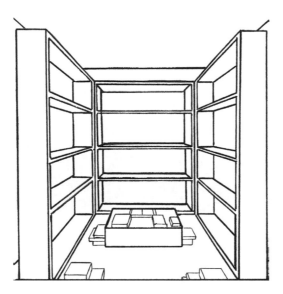

Here's the problem with this image: It's just too "meh." I know that "meh" isn't necessarily a deep critique of anything, but the sentiment is universal. The room is just too tidy, and definitely doesn't feel lived in. So, let's take pencil to paper yet again and produce something more appropriate:

Much better throughout, I think. This room now has a stronger sense of history to it, as if someone has actually opened these books and used them before. Still, there's something not quite right with it . . .

Lighting! Texture! Grit!

Our image still needs more life added to it. Remember that the scene says that it's clearly lit by candlelight and that our environment is supposed to feel old. So we are going to have to take into account our light source, distressing on the textures presented, and changes in texture itself. Thus we arrive at this piece, closer to our overall purpose, and applicable not just to our regular predisposed piece of narrative, but also to other productions involving this property and this environment:

Notice that the environment is drawn to style, by which I mean that the image is done with a concept in mind. Our characters fit the environment, and it can coexist with our previous examples of locations for this concept.

So, we're done! Yay! We can go and take a long deserved . . .

. . . oh, yeah, we still have to draw the narrative.

We need to know whether this environment will work on paper and be applicable to shots and beats in the story. And so, gentle reader, we head on to the final stage of our little project.

GET THE PICTURE?

Before we get started, I'm going to go ahead and assume that you've actually *reread the small script* we've been given at the beginning of these last

chapters, to get a better sense of our task at hand. If not, now's your chance. I'll wait here

Welcome back! Now that you remember more clearly what type of story this is, let's get a couple of blocking issues out of the way. First, let's break down how this story is meant to be seen:

- These events take place from the perspective of the viewer, so we'll be drawing each scene in first-person view (or a point of view shot).
- Seeing as how our environment leads directly to the desk and our character won't be moving much from his spot, you'll probably be doing a lot of one- to two-point perspective shots throughout.
- The focus of the scene is to introduce the environment and the feel of the story, so our first panel should be clear enough that we get a sense of where we are at, and then we can go ahead and break down shots to better illustrate said focus.

With all this in mind, let's draw a *thumbnail* of what we want our scene to look like, with a panel arrangement that is appropriate for what we are trying to achieve:

It's worth noting here that I am arranging the scenes in the form of a comic because the original assignment was, in fact, a comic. However, this script can be readapted to be used in the format of animation storyboards, animatics (or a film reel made completely from storyboards for editing purposes), or game-level animations, depending of your preferred method of production. What's important here is to maintain the *core concept* and to get the background to function in service of the story, regardless of what medium is being used.

We've got multiple shots, each meant to convey an individual pacing. Using this, we can now create a full page of comic art. We can go about placing the information within the thumbnails onto the page in a couple of ways (we can reproduce these thumbnails lightly onto Bristol board by using them as visual reference, for example, or we can copy them, enlarge them, and use a light table to trace those thumbnails, or scan them into Photoshop, and render them there—whatever your preferred method is, go for it), but from there, we basically start working the way we've been going at it all this time: start with your line art, add texture when necessary, and make sure that your concept and focus stays clear throughout. With this workflow in mind, let's look at the final product:

Voilà!

Our page is ready to work within a larger story, and our concept is now clear!

There you have it, folks: we're done with our first page. Yes, you read that right: our first. I hope all these skills have become clearer in your mind, because you are about to use them!

The following pages contain the next two pages (referred here as "screens") of story, continuing the saga.

NICK KRINGLE, MAN OF XMAS

SCREEN 2

Panel 1: Wide establishing shot of a misty night in a suburban alley-way (between two houses, not deep in a city). Long shadows stretch from back to the front, as the distant view of a little girl (about seven years of age, dressed in her pajamas) runs alongside a young boy (about ten years of age, leading the girl along by the hand) toward the viewer from a distance. The little girl grips a stuffed teddy bear tightly.

Old Elf (caption): "This all happened one dark night, one far removed from that blessed night of song. A night filled with danger."

SFX: Screech!!!

Panel 2: Shot of the girl, side to the waist, as she dashes forward, passing bushes and a gate. A long stretching shadow extends to her side, and looks like long fingers angling to grab her. The girl looks petrified. The boy continues to lead on, looking forward.

Girl: Unh . . . huh, oh, please, Dr. Bearington, make it go away!

Boy: C'mon, Cindy! Don't look back, okay?

Old Elf (caption): "You see, there are nights when children, as well as the innocent of heart, do not wish for toys and candy."

Panel 3: Closer on the girl, wide-eyed and terrified, as she turns to see behind her, and the shadow of her assailant seems to get closer and closer. The boy is in front of her, looking behind as well, but at the little girl (he is not completely turned). In the background, far ahead, we can see a fence enclosing the alley.

Boy: I said don't . . . !

Girl: . . . No! . . .

Old Elf (caption): "But rather, to be delivered from peril."

Panel 4: High angle shot of the boy and the girl, reaching the fence, pushing it to no avail. The girl's teddy bear has hit the floor, and the shadow, now with evil eyes and mouth form, gets closer to her.

Boy: . . . Oh, no. I can't get it . . . unh!

Girl: . . . Mommy!!! Daddy!!! Help!!!

SFX: Clink! Ka-Clink!

Old Elf (caption): "It is on those nights, when the world calls out for aid."

Panel 5: Girl, turned around facing her unknown assailant, looks onward in terror, gripping the gate behind her. Her brother holds her other hand, with a look of panic on his face. The shadow on the wall next to the girl is almost upon her.

Shadow (off-panel): . . . grrrrrrrrr . . .

Girl: . . . Help . . .

Old Elf (caption): " . . . that the jolly sweet caretaker disappears . . . "

Panel 6: Same shot, but now the girl looks upward, startled, while the shadow, which a moment ago was so close, is now recoiling, as if backing away.

Voice (off-panel, above): Chin up, kid!

Old Elf (caption): "And he becomes a different man."

SCREEN 3

Panel 1: Thin panel of black boots with white tops connected to red pants, landing on the ground of the alley.

SFX: THUMP!!

Old Elf (caption): " . . . a man of power . . . "

Panel 2: Close on a belt buckle with a stylized reindeer logo connected to a black belt (this is also a slim panel, just as the first).

Old Elf (caption): " . . . a man of courage . . . "

Panel 3: Big reveal of Nick Kringle! He stands looking in the direction of the viewer, wearing a stylized version of his "Santa Claus" uniform (closer to an "adventurer/action hero" look; think Doc Savage–GI JOE vibe) as well as dark gloves and a pair of goggles. To the side of his belt, next to a pouch (he has two to each side) he has strapped on what looks like a reindeer-symbol-emblazoned walkie-talkie. A long bag is strapped upon his shoulder and he is squared off for a fight. The kids stand behind him, shocked at what they see. In the foreground, creepy monster hands retract from the scene, as the shadow that was once following the girl looks to have a bit more form.

Old Elf (caption): " . . . a man . . . "

Nick Kringle: This dirtbag's due for a nap!

Old Elf (caption): " . . . of ACTION!"

Old Elf (caption; continued): "He is a sentinel of justice, using his vast array of tools and treats to protect the good . . . from the *naughty*! He is Nick Kringle, Man of XMAS!!!"

Nice! We get monsters and action!

With the first page, I took you through the steps a designer goes through to create visual storytelling. Now it's your turn!

Using the pages of script presented in this chapter, I am now commissioning you to produce an environment that can fit with the concept presented and can be adapted for the use of narrative and storytelling development. You can even use the script I've provided and draw some action sequences to demonstrate your environment. To help, I'll start you off with some drawings of the two children that show up in our script:

I could also include a drawing of the monster featured within the narrative as well, but I think you'll have more fun if I just let you come up with your creature yourself (here's a hint regarding design: I named the creature in future scenes "the humbug," so go from there). Anyway, go ahead and get started! Let's see what you've got, and take this story onward!

Oh, and speaking of next stops, let's find out whatever happened to our pal Felix Fahrenheit.

CODA: Exit the Scene

AFTERWORD

Here we are, then. End of the road.

Well, actually, no—it doesn't have to be the end of the road for you. From this point on, all sort of environment-related opportunities have been opened for your use and design, leaving you with the possibility of more adventure and excitement to be had with backgrounds. I wish I could tell you that this book is the definitive word on background design, but the truth of the matter is that such a book, in all honesty, doesn't really exist. You'll find that as you continue to study environments for storytelling, you'll constantly be presented with new shortcuts, new tricks, and new methods for how to render environments effectively. However, at their core, these methods are derived from the concepts presented here, and that's enough for me to feel satisfied with my instruction. I hope that you feel happy with what you've learned as well.

Like any book on layout design and illustration, this book may have had one writer, but it had many creators, and I couldn't leave without thanking a few people who've helped me along the way.

First of all, thanks to Focal Press for offering me the opportunity to write a book on a subject I love dearly (as well as your patience and support, which—this being my first technical book—helped immensely). I would especially like to thank to Anais Wheeler, Lauren Mattos, and David Bevans for taking a chance on this book—and a chance on me! Hope you enjoyed the results!

Thanks to both of my tech editors, Alex Buffalo and Aubry Mintz, for all their help and suggestions. Sometimes when you are in the middle of writing, you tend to be too connected to the work to be arbitrary, and your critiques brought me back to earth. I would also like to thank Bryan Tillman,

who basically suggested the book in the first place and who has been an awesome friend and compatriot throughout, as well as the Media Art and Animation Faculty of the Art Institute for their support and friendship. Special thanks to Professor Charl Anne Brew for her help in breaking down grids—specifically, the two-point vertical grid. Thanks a million.

To my parents, family, and friends, thanks for all the love, support, and over-all, patience. I know I can be a bit of a pain when my back's against the wall, so I adore you for all that you put up with. As for my students: projects are due on Monday, and no late work will be accepted. You know the drill.

Finally, thanks to you, kind reader, for taking such an interest in background design. I hope this book serves you not only in your current assignments but in future ones as well. I also hope you are now as passionate about your environments as I've become. Take care, and keep drawing those perspective grids!

—Elvin A. Hernandez

ADDITIONAL RESOURCES

Here are some resources to help expand your environment and storytelling studies:

- For a more expanded look at character design, a subject I touch upon in this book, check out Bryan Tillman's book *Creative Character Design*. Character sheets, design study, and iconography are expanded upon in more detail, and it's a good companion book to this one, in particular because it goes into characters as much as I tried to go into background design.
- Reference sites—including blogs such as http://klangley.blogspot.com, which contains various examples of character and environment designs used in animation throughout the ages—can add a sense of history to your understanding of the concepts covered here. You can also see how different artists handle some of the same issues you might face as an artist.
- Sites such as http://deviantart.com showcase established, new, and aspiring artists, as well as various methods of environment design, and can also indicate how other mediums handle some of the same concepts covered here.
- Expand your horizons (sorry) in terms of your reference points: consider magazines, books, pictures, journals, and the news (both print and digital), as well as any source of visual information that is not limited to the things you have already been exposed to (the things you like, basically). In short, look at everything!

CREDITS

- All "The Solution" and "Dark Legacy" Artwork is used with permission from Kaiser Studio Productions (kaiserstudio.net).
- All penciled and inked artwork produced by Elvin A. Hernandez.
- All color work on "Exit" produced by Bryan Tillman.
- All color work on "The Solution" produced by Kristen Peck.
- All other artwork property of Elvin A. Hernandez.
- "Champ" (and "Felix Fahrenheit") created by Elvin A. Hernandez.

Index

T - #0209 - 111024 - C60 - 276/216/11 - PB - 9780240820538 - Gloss Lamination